IMAGES
of America

EARLY
SANTA ANA

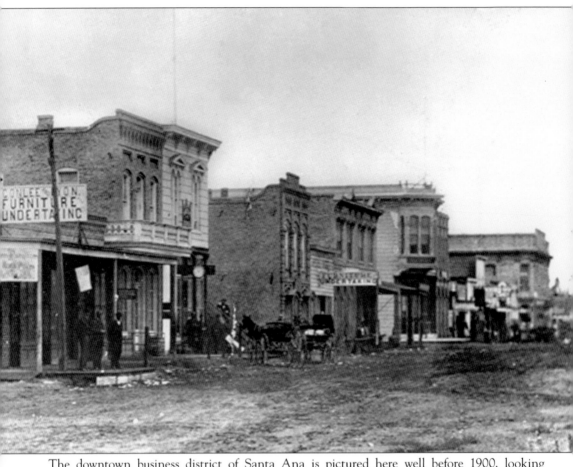

The downtown business district of Santa Ana is pictured here well before 1900, looking like a town from an old Western movie. Horses and carriages were the main mode of transportation on the dirt streets. The enterprising proprietor of the business at far left of the photograph was both a custom furniture maker and an undertaker. (Courtesy Bowers Museum of Cultural Art.)

ON THE COVER: City founder William Spurgeon and his wife, Jennie English, pose on the front porch of their home in the 1870s. (Courtesy Santa Ana Public Library History Room.)

IMAGES
of America

EARLY
SANTA ANA

Marge Bitetti, Guy Ball, and the
Santa Ana Historical Preservation Society

ARCADIA
PUBLISHING

Published by Arcadia Publishing
Charleston SC, Chicago IL, Portsmouth NH, San Francisco CA

Printed in the United States of America

Library of Congress Catalog Card Number: 2005934839

For all general information contact Arcadia Publishing at:
Telephone 843-853-2070
Fax 843-853-0044
E-mail sales@arcadiapublishing.com
For customer service and orders:
Toll-Free 1-888-313-2665

Visit us on the Internet at www.arcadiapublishing.com

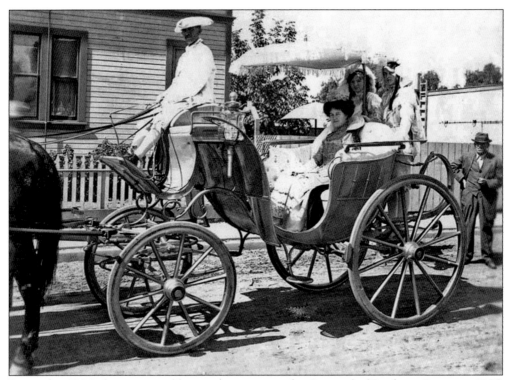

Pictured *c.* 1906, the queen and her court reign over the Carnival of Products. Begun in 1905, the Parade of Products offered local merchants and growers an opportunity to promote their goods and services.

CONTENTS

Acknowledgments 6

Introduction 7

1. 1860–1889 9

2. 1890s 21

3. 1900–1919 39

4. 1920s 65

5. 1930s 87

6. 1940s 113

Bibliography 128

ACKNOWLEDGMENTS

Writing about the history of a city is not possible without the courageous pioneers who traveled west to California looking for the opportunity to follow their dreams and build a future to pass on to countless generations.

Thanks to the photographers and those people who keep recorded histories safe and secure. To the decades of historians, who have valued and treasured the past and preserved it for future residents, inside and outside of Santa Ana.

I wish to thank Tony and Danielle for their assistance, time, and talent. Thanks to God, the creator of all, who inspires and blesses people with the courage to take risks and make history happen. Thanks to Arcadia Publishing for granting us the opportunity to write about the history of Santa Ana.

INTRODUCTION

Back in 1886, Santa Ana was a booming community with some 2,000 residents. The city was the center of what was called the Santa Ana Valley: home to over 10,000 men, women, and children—many of whom had recently moved here to create a better life for themselves.

Maybe these settlers listened to the real estate sellers who were promising new land at $50 to $100 an acre. Maybe they were just trying to get away from the poverty and injustice of the South. Perhaps they were tired of the cities and the lack of opportunities in Northeast. For whatever reasons, they came here—farmers and bankers, shopkeepers and laborers, lawyers and blacksmiths.

The whole Southern California basin grew quickly, thanks to these "explorers" who were willing to uproot their families and take a chance on new and unfamiliar land that promised them the dream of finding gold in California.

With this new volume of vintage photographs, we celebrate 120 years of growth of the city of Santa Ana. We celebrate the dreams realized—and even the dreams not realized. We celebrate the people who made this city happen.

To bring this book to you, we tapped archives of several historic institutions that are not commonly used by photograph-historians. The bulk of the original photographs in this book came from the collection of the Bowers Museum of Cultural Art—a museum founded in 1936 with a rich history of servicing the community and now the world.

We were given access to the collections of our good friends at the Orange County Historical Society, a wonderful organization that has been active since 1919. We received help from the County of Orange Historical Archives, a dynamic resource on Orange County history. And of course, we were helped by the archives of the Santa Ana Public Library's History Room—a phenomenal resource of historical information on the city.

We are also very proud that we were given permission to include photographs from several local families who wanted to share images of their parents, grandparents, cousins, and friends.

I'd like to personally thank a few individuals who made our life so much easier while creating this book: Alice Bryant and her assistant Jennifer Ring at the Bowers, Phil Brigandi and his assistant Chris Jepsen at the OC Archives, Betsy Vigus at the OC Historical Society, and Cheryl Eberly at the SA History Room. I also want to thank Helen Moraga, Mary Garcia, Harvey Reyes, Rob Richardson, and Carol Anne Robinsen for sharing their family photographs. And a big thanks to Steve Cate for his caption help with additional facts and information.

While we could not have created this book without the help of our photograph sources, we'd like to offer a big thank you to coauthor Marge Bitetti, who graciously offered to develop, research, and finish work on this book when our own resources drew thin. Without her, this book would not have been completed.

Enjoy this journey into the past, flavored by the people and businesses that created the history of the city of Santa Ana.

—Guy Ball
Santa Ana Historical Preservation Society

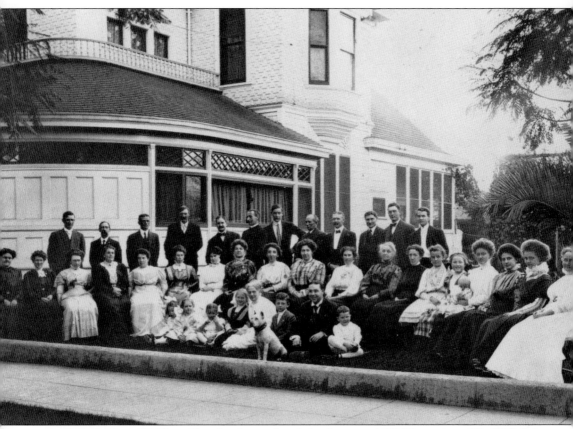

Dr. Willella Howe-Waffle and her family pose beside her house in 1907. The saving of Dr. Willella's home from demolition was the catalyst for the formation of the Santa Ana Historical Preservation Society in 1974. Since then, the society has proudly carried the banner to preserve and celebrate the history of Santa Ana and early Orange County through its various programs and projects. Information about the society, as well as extensive historical information and vintage photographs, can be found on the Web site at www.SantaAnaHistory.com.

One

1860–1889

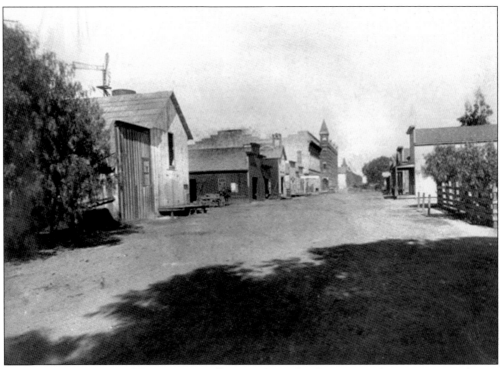

By the 1880s, the city of Santa Ana really started to take shape. Less than 20 years earlier in 1869, William H. Spurgeon purchased 74.27 acres from Jacob Ross, who earlier had purchased part of the vast Mexican land grant from the Yorba family. Spurgeon quickly got to work to create his dream—the city of Santa Ana. Pictured is Sycamore Street, looking north from Third Street. (Courtesy Bowers Museum of Cultural Art.)

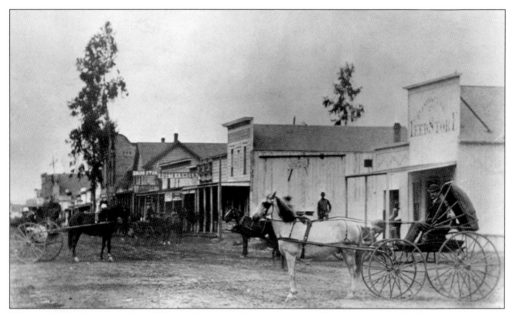

This c. 1882 photograph of Main Street looks north from Fourth Street. In the foreground is Charles E. French, the postmaster of Santa Ana. In 1886, he was also one of the main promoters of the Santa Ana streetcar line. He built the opera house in Santa Ana and was said to have one of the most elegant homes in the city. (Courtesy Bowers Museum of Cultural Art.)

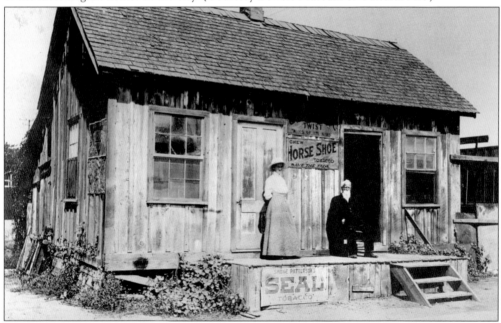

City founder William Spurgeon and his wife, Jennie English Spurgeon, are pictured on the front porch of this board-and-batten store building. In 1869, Jacob Ross sold 74.27 acres to William Spurgeon and Ward Bradford for $8 an acre. This land was originally part of the Rancho Santiago de Santa Ana. This building served as a home, the post office, and the general store. It was located near Broadway and Fourth Streets. The photograph is believed to be from the 1870s.

The D. W. Swanner Grocery store was on the ground floor of the Spurgeon Building, located at the southwest corner of Fourth and Sycamore Streets. This photograph, believed to be from 1887, shows members of the Swanner family. Pictured, in no particular order, are John A. Swanner, Charles D. Swanner, unidentified, and D. W. Swanner. (Courtesy Bowers Museum of Cultural Art.)

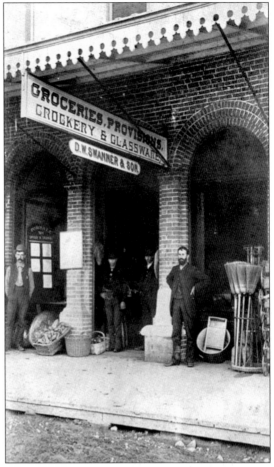

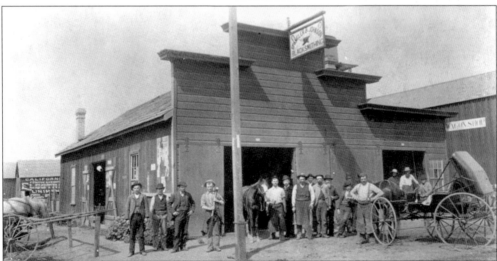

Pictured here in 1895 is Sprangler's and Johnson's Blacksmith Shop. The wood-frame building was located on Sycamore Street between Second and Third Streets. (Courtesy Bowers Museum of Cultural Art.)

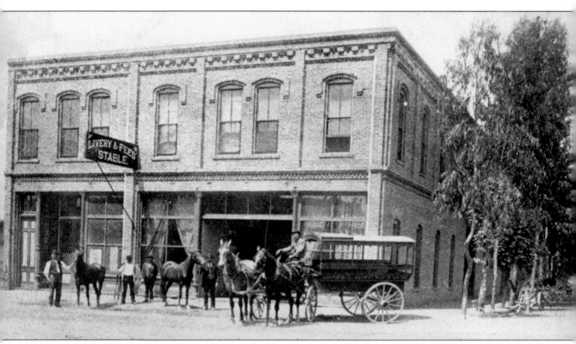

During the 1880s and 1890s, livery and feed stables were important to daily transportation needs and were a vital industry. This livery stable is believed to be on Fourth Street. Livery stables rented horses and carriages, sold feed, and often boarded horses. (Courtesy Bowers Museum of Cultural Art.)

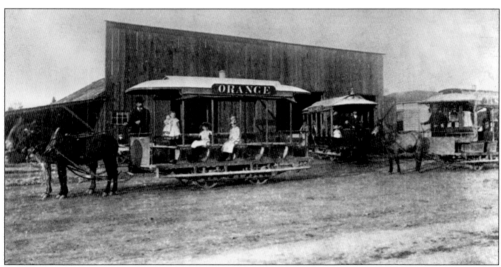

The Santa Ana carbarn pictured here in 1889, three years after Santa Ana was incorporated as a city, was located on West Fourth Street. Horse-drawn streetcars linked Santa Ana with the nearby cities of Tustin and Orange and the Southern Pacific depot.

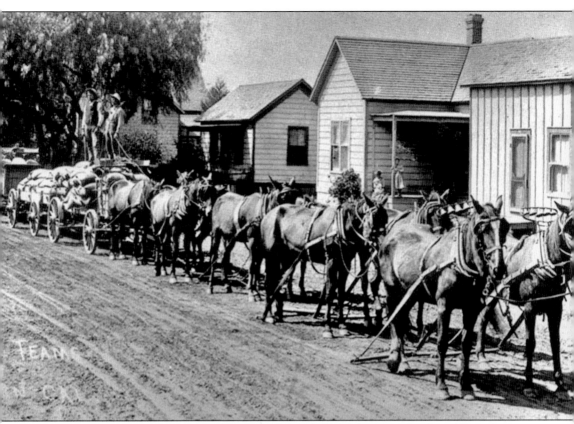

In the late 1880s or 1890s, men haul barley on Fourth Street between Birch and Ross Streets. (Courtesy Bowers Museum of Cultural Art.)

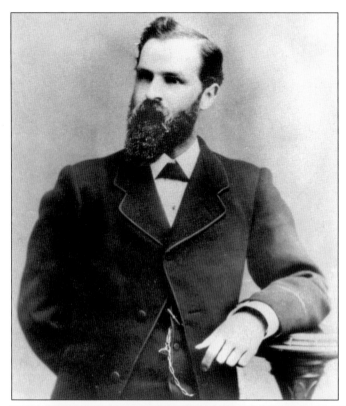

The dapper William S. Bartlett (1842–1914), a banker, moved to Santa Ana from Oakland. He married Franklina Gray in 1878 and they then moved to Tustin. He started a bank with H. J. Smith, later known as the Commercial Bank of Santa Ana. David Halladay was president, and Bartlett served as the secretary. (Courtesy Orange County Historical Society.)

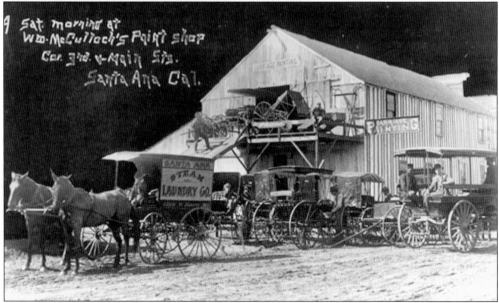

Before the 1900s, printers played an important role in the community. They made it possible for many people to share local news. The work of the early print shops also served as a way of documenting the past. This photograph shows a typical busy Saturday morning at the print shop of William McCullock, located at Third and Main Streets. (Courtesy Bowers Museum of Cultural Art.)

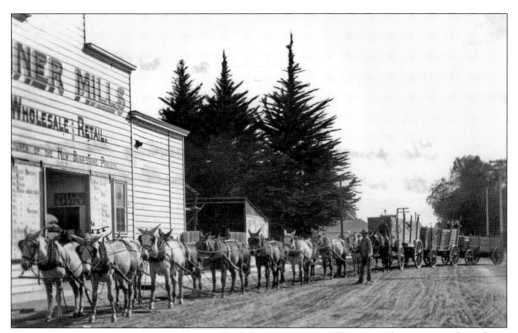

Teams of mules were used to haul heavy loads between cities. This 14-mule team stands in front of Banner Mills on French Street, between Third and Fourth Streets.

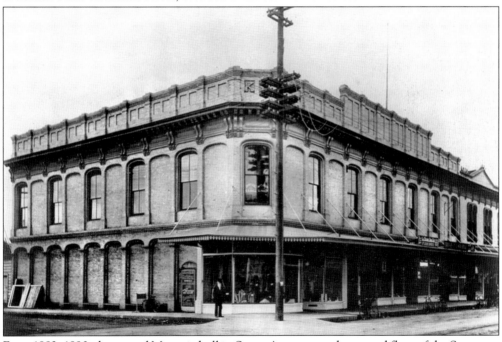

From 1882–1890, the second Masonic hall in Santa Ana was on the second floor of the Spurgeon Building, located at the corner of Fourth and Sycamore Streets. The Masons had strong roots in the city of Santa Ana starting in 1870, when the population of the city was just 500. A group of Masonic brothers gathered to help a widower with six children who had arrived in Santa Ana with no money, work, or food for his children. The first master of the Masonic lodge was Albert W. Birch. (Courtesy Bowers Museum of Cultural Art.)

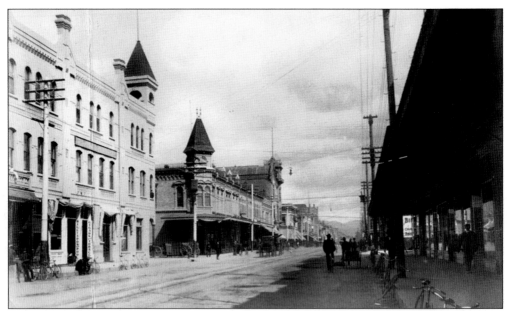

In the 1890s, Santa Ana's Fourth Street is dusty and unpaved, but the number of buildings shows the development of the city. (Courtesy Bowers Museum of Cultural Art.)

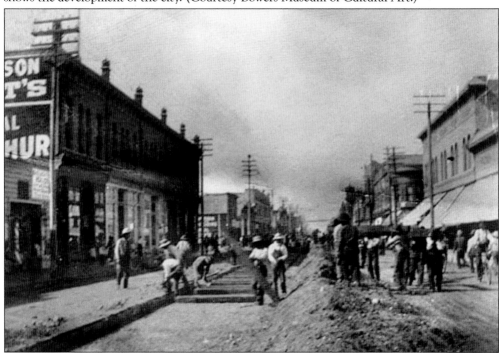

Legislation such as the Alien Law of 1913 prevented immigrants from owning land in California. At the time, African Americans were forced into segregation and restricted from using public facilities. Chinese laborers were used in Santa Ana as laborers, especially for railroad construction. Hardworking Chinese, African Americans, and many others from various ethnic groups played a crucial though uncredited role in settling California. (Courtesy Bowers Museum of Cultural Art.)

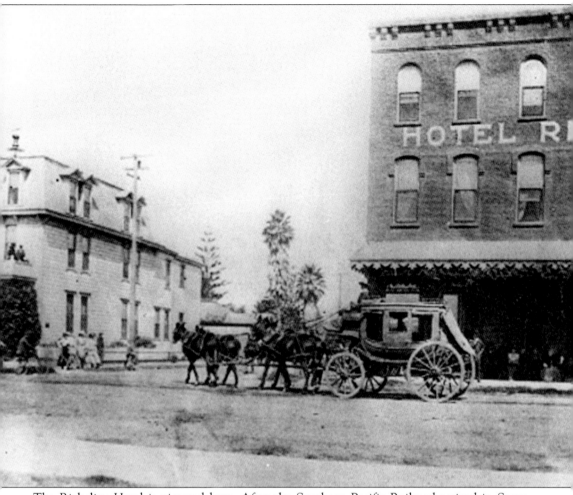

The Richelieu Hotel is pictured here. After the Southern Pacific Railroad arrived in Santa Ana, Henry Neil started a stage line that would take people from the Santa Ana depot to San Diego—a distance of 89 miles. In this 1877 photograph, the stage is stopped at the Hotel Richelieu, which was located at Fourth and Ross Streets.

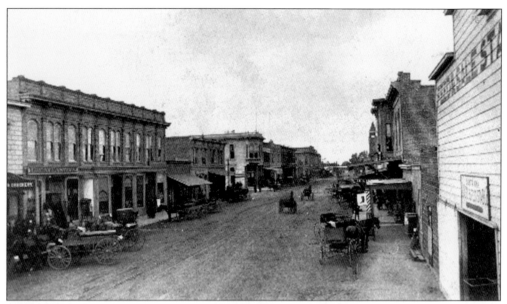

This was Fourth Street looking west from Bush Street, around 1885. (Courtesy Bowers Museum of Cultural Art.)

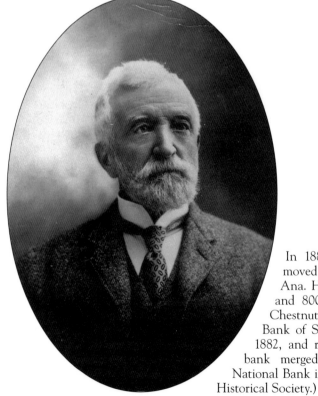

In 1880, Daniel Halladay (1826–1916) moved from Batavia, Illinois, to Santa Ana. He owned several acres in the 700 and 800 blocks of First Street, over to Chestnut. He helped form the Commercial Bank of Santa Ana, served as president in 1882, and remained on the board until the bank merged with Farmers and Merchants National Bank in 1910. (Courtesy Orange County Historical Society.)

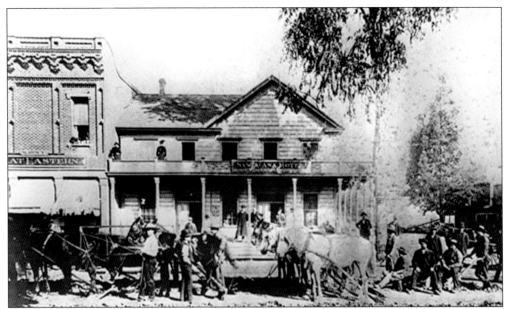

In 1878, D. M. Dorman built the Santa Ana Hotel. In 1887, owner James W. Layman moved the hotel to Mortimer and Fruit Streets. In this 1880s photograph, foreman John Cubbon and his crew are grading the street in front of the hotel. The men to the right of the photograph appear to be supervising the work. (Courtesy Orange County Historical Society.)

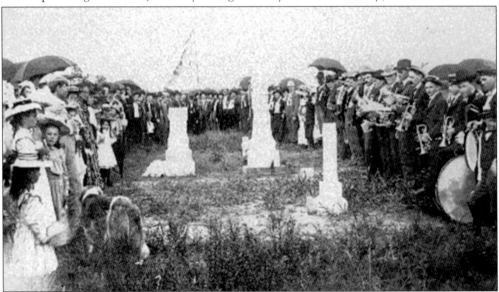

In the 1870s, the pioneer Ross family suffered the deaths of two children. Part of the land owned by Ross, near the corner of Eighth and Ross Streets, was set aside as a cemetery where the children were buried. In 1878, the bodies were moved to what is now the Santa Ana Cemetery, located in the north part of the city at 1919 East Santa Clara Street. When Fairhaven Memorial Park was established in 1911, it was located at 1702 East Fairhaven Avenue next to the existing Santa Ana Cemetery. In the 1800s, people would include the dead in their celebrations. Fairhaven Cemetery is seen in this early celebration, complete with a brass band. (Courtesy Orange County Historical Society.)

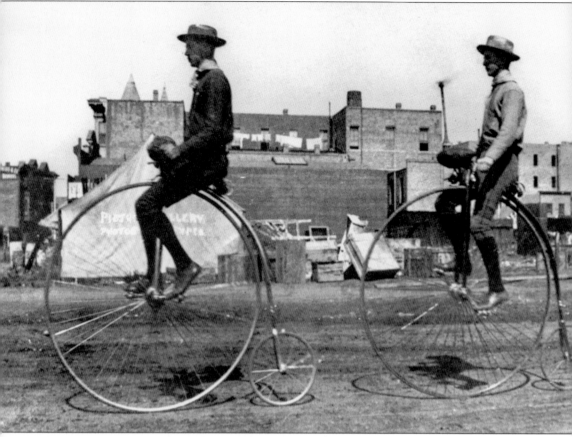

In 1889, James Irvine Jr. rode from San Francisco to San Diego to look at the vast land that he had inherited from his father three years earlier. James Irvine Sr. purchased part of the original Spanish land grant and added to his holdings by buying out other landowners in the area. By 1876, the Irvine family owned 109,000 acres. In this photograph, James Irvine Jr. is riding a velocipede. These bikes were not comfortable and therefore not very popular. There was a large wheel in the front, which ranged from 42 to 62 inches and two tiny wheels in the back. Irvine is wearing knickers and high leather dress shoes; Harry Bechtel accompanies him. (Courtesy Orange County Historical Society.)

Two

1890s

By the 1880s, there were eight blacksmiths in the city. In early Santa Ana, a blacksmith was an essential professional trade for metal work and tool making as well as animal shoeing. A skilled blacksmith was viewed as a master craftsman. (Courtesy Orange County Historical Society.)

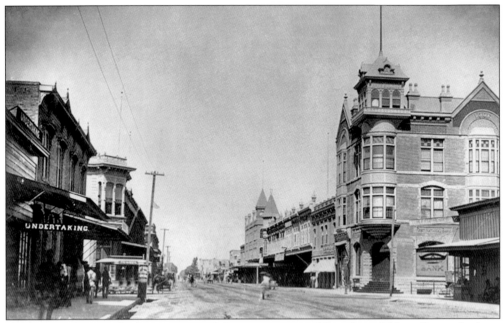

This 1890s photograph shows a view of the intersection of Fourth and Main Streets looking west on Fourth Street. (Courtesy Bowers Museum of Cultural Art.)

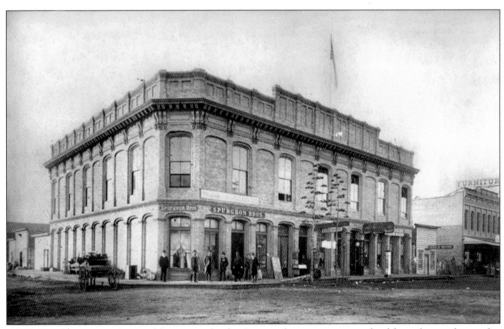

In 1882, the Spurgeon Building was built. It was large two-story building located on the corner of Sycamore and Fourth Streets. Inside the Spurgeon Building was a general mercantile store, Wells Fargo office, and the office for the water company. (Courtesy Bowers Museum of Cultural Art.)

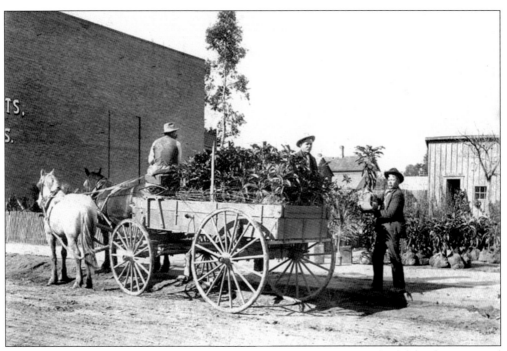

In the 1890s, new immigrants, often from Mexico or Italy, frequently did landscaping and planting work. The men in this photograph are loading trees into a wagon to transport them to where they will be planted. (Courtesy Bowers Museum of Cultural Art.)

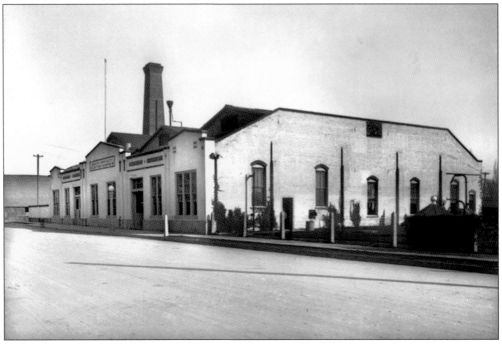

Pictured is the Brick Water Works plant during the late 1880s. William Spurgeon was responsible for the city's water supply. In 1889, the artesian wells Spurgeon built supplied the water needs for the growing city. (Courtesy Bowers Museum of Cultural Art.)

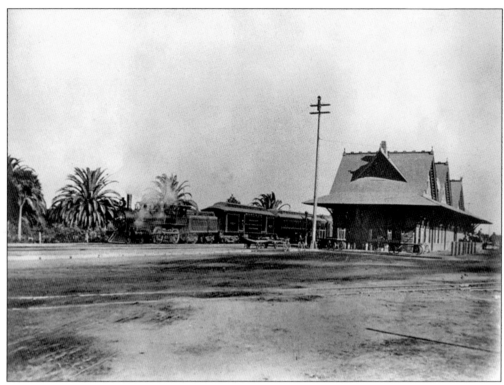

The Santa Fe Railway Station opened on September 15, 1887. This was an important development in the growth and prosperity of the city. This photograph of the Santa Fe Railway Depot dates between 1887 and 1905. (Courtesy Bowers Museum of Cultural Art.)

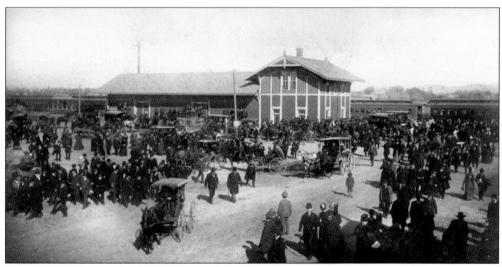

Passengers gather at the Southern Pacific Railroad station. In the background is the wood-framed train depot freight warehouse, which was located on Fruit Street. The depot was built in 1878, one year after the railroad came to Santa Ana. (Courtesy Bowers Museum of Cultural Art.)

The Santa Ana Water Tower still plays a vital role in the city's water by providing a pressure equalizer for the water system. The town's water supply began with Spurgeon in 1869, when he built an artesian well and small water tower for the residents.

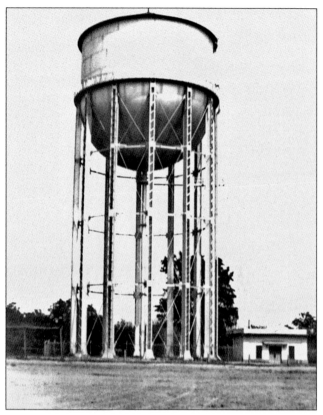

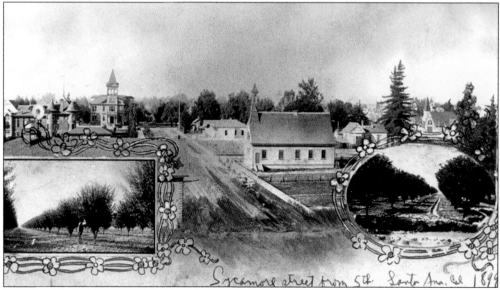

This postcard shows a view of Sycamore Street from Fifth Street, c. 1899. In the photograph, numerous church steeples tower over the city. In December 1870, the first church to be established in Santa Ana, the Methodist-Episcopal church, met in the home of Mr. and Mrs. W. H. Titchenal. Many other faith traditions soon followed. These pioneer churches formed the moral center of the community. (Courtesy Bowers Museum of Cultural Art.)

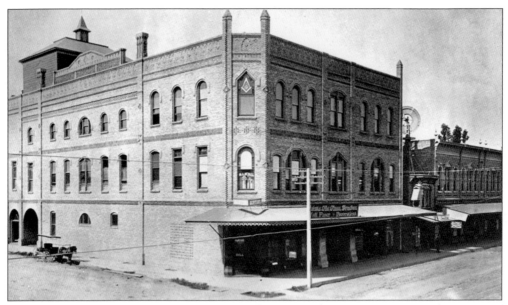

C. E. French built an elegant opera house, known as French's Opera House, on the corner of Fourth and Bush Streets. It opened July 11, 1890, with the world-famous Polish actress Madame Helena Modjeska performing as Lady Macbeth in the Shakespearian classic. Historic records note that the theater was filled, and the opening night benefit raised $7,000 for the Orphan's School in Anaheim. (Courtesy Bowers Museum of Cultural Art.)

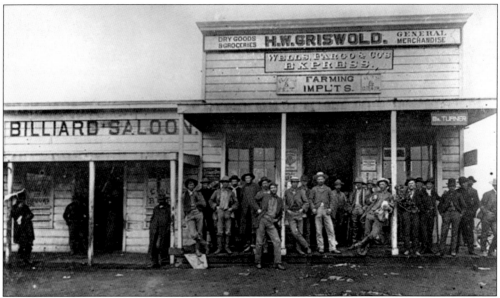

Several men gather in front of the H. W. Griswold General Merchandise store. Inside the store was a Wells Fargo office. In 1874, Wells Fargo first opened service in Santa Ana. Next to the general store was the Billiard Saloon. The saloon became popular in early Santa Ana, and by 1902, there were seven saloons in the city. This problem was the focus of the Women's Christian Temperance Union (WCTU), who actively campaigned to close all bars in the city. In 1903, a ballot proposition passed that forced the closure of all saloons. (Courtesy Bowers Museum of Cultural Art.)

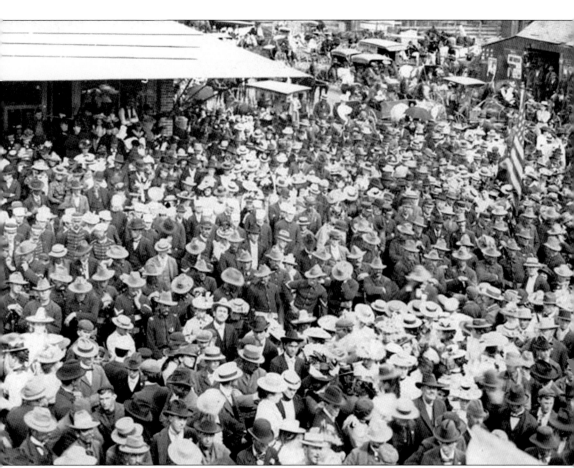

Company L is pictured leaving Santa Ana to fight in the Spanish-American War. The war lasted from April 1898 until August 1898. Men in the California National Guard were called into service to serve as part of the 7th California Infantry. After spending months in readiness, the war ended before the unit ever shipped out for actual combat. This photograph was taken on the corner of Fourth and Birch Streets. (Courtesy Bowers Museum of Cultural Art.)

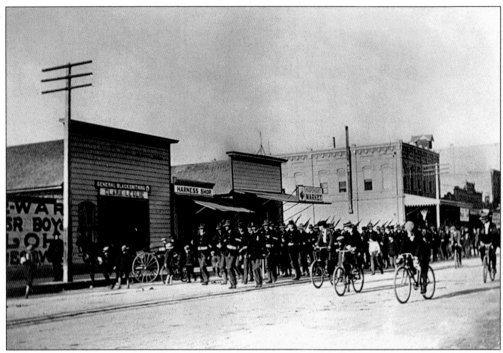

In 1898, Santa Ana National Guard unit Company L was called to active duty to serve in the Spanish-American War. Prior to this active duty, Company L was called Company F. The unit had 58 enlisted men and three officers, and had a long and proud history. In the 1950s, the unit's name changed to Company A, 161st Armored Infantry Battalion. (Courtesy Orange County Historical Society.)

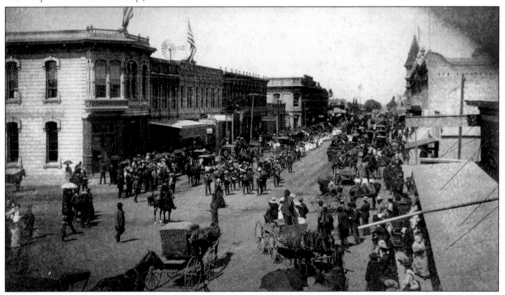

People lined the street for this event that was related to the Spanish-American War. A parade seems to be coming to an end in the center of the street. The flags on all the buildings in this photograph indicate the strong patriotism the community had. The Spanish-American War lasted from April to August in 1898. (Courtesy Bowers Museum of Cultural Art.)

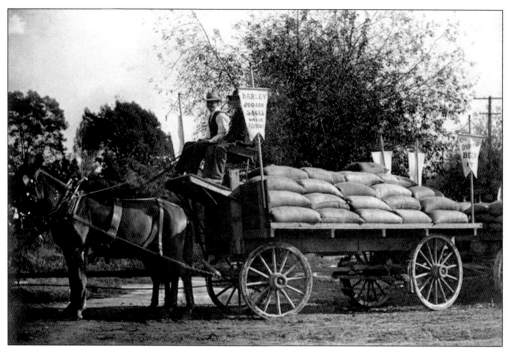

This unidentified man is hauling sacks of barley. According to historian Jim Sleeper, barley was one of the best grain crops in Orange County from the 1880s until about 1900. Because the grain used mainly as feed for the horses, barley crop production declined as cars became more popular. (Courtesy Bowers Museum of Cultural Art.)

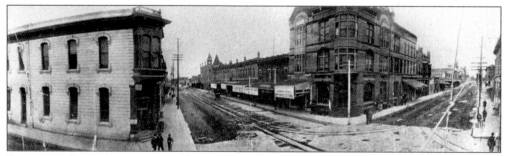

Downtown Santa Ana is pictured here in 1890, on the corner of Fourth and Main Streets. On the right of the photograph is the First National Bank building. Down the street from the bank is the Rossmore Hotel. (Courtesy Bowers Museum of Cultural Art.)

In the 1890s, Santa Ana had many hotels because it was a major stopping point for people on their way to Los Angeles in the north or San Diego in the south. This view, taken from the Brunswick Hotel, looks north. In the foreground is Fifth Street. (Courtesy Bowers Museum of Cultural Art.)

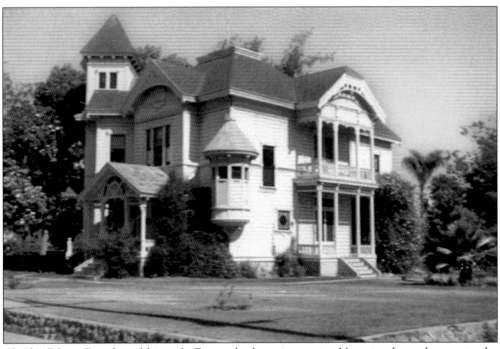

Charles Edwin French and his wife, Emma, built an impressive Victorian home known in the community as the French House, located at Ninth and Spurgeon Streets in the French Park neighborhood. Built in 1888, the house spanned half a city block. In the 1960s, the home was demolished to provide space for a parking lot.

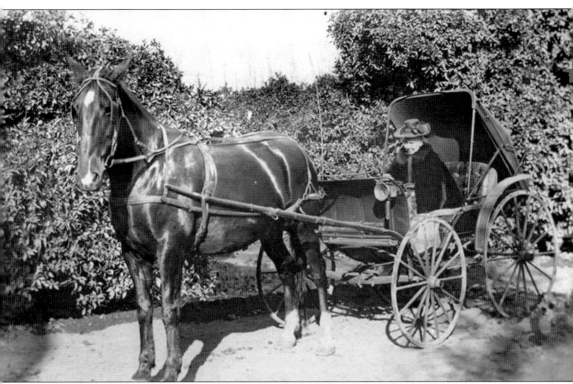

Out for a ride, this unidentified woman in a buggy is the image of independence. Her clothing and fur trim indicates that she might have been financially secure. (Courtesy Bowers Museum of Cultural Art.)

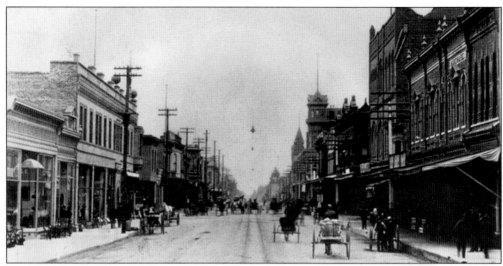

By the end of the 1890s, Santa Ana was a thriving city with a growing population of 3,600 and modern inventions, evidenced by the streetcar tracks in the street. This view of Fourth and Bush Streets looks west. (Courtesy Bowers Museum of Cultural Art.)

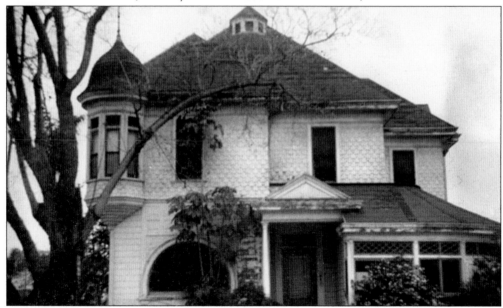

This is the home of Dr. Willella Howe-Waffle, a physician who worked without a vacation for 44 years, serving the people of Santa Ana. She had a great sense of duty to the poor and unfortunate. Born in Virginia in 1854, she married Dr. Albert Howe and moved to San Francisco in 1874. In 1881, they moved to Santa Ana. She received her medical degree from Hahnemann Medical College. After divorcing Dr. Howe, she married Edwin Waffle in 1898. She was one of the most well known of the early women doctors in Orange County. In 1889, she and Dr. Howe had a Victorian home built for them on Bush Street. She died in 1924 at the age of 70 while delivering a baby at the Santa Ana Hospital, which was located on Washington Street. Slated for demolition, the house was saved in 1974 by Adeline Walker, Betty Biner, and other preservationists. It was relocated to 120 West Civic Center Drive, and has been restored and preserved as a house and medical museum. (Courtesy Orange County Historical Society.)

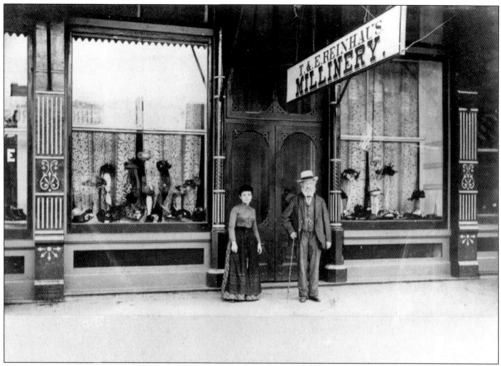

This is a late 1890s photograph of the T. and E. Reinhaus Millinery store. By 1907, the Reinhaus brothers owned a popular department store on Fourth Street. As towns became more cosmopolitan, dress and fashion became more important. In the 19th and early 20th centuries, a well-dressed woman wore hats inspired by the latest Paris and New York designers. (Courtesy Orange County Historical Society.)

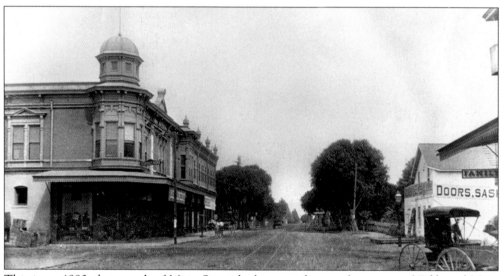

This is an 1880 photograph of Main Street looking north near the corner of Fifth and Main Streets. (Courtesy Bowers Museum of Cultural Art.)

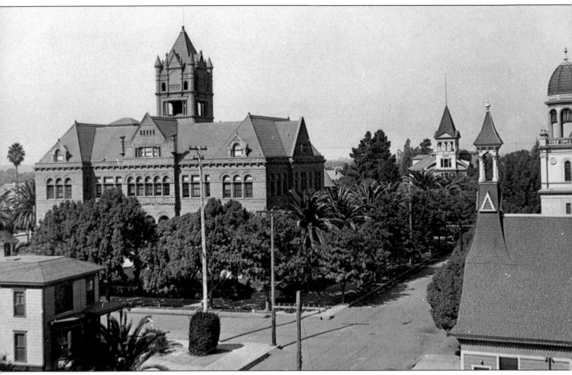

Sycamore Street is pictured here in the early 1900s. Sycamore trees grew naturally in and around the Santa Ana area. City father William Spurgeon had an adventurous spirit when he rode into the area that would become Santa Ana; the yellow mustard greens were so thick that Spurgeon got off his horse and climbed a sycamore tree to survey the land.

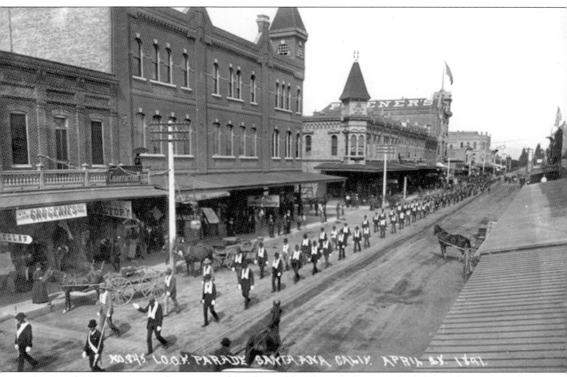

On April 28, 1891, a parade sponsored by the Odd Fellows lodge marched down the center of the city. On the left of the photograph is the Brunswick Hotel. This view of Fourth Street looks east from West Street. West Street was later renamed Broadway. Parades served many purposes in the 1890s including promoting events and for celebrations. (Courtesy Bowers Museum of Cultural Art.)

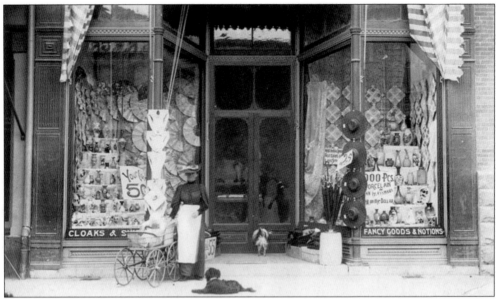

This Santa Ana storefront was photographed on a summer day near the end of the 19th century. The store featured items for ladies including notions, porcelains, and sewing items. Hats and fans were useful for the hot summer days. Outside of the store, two pet dogs wait good-naturedly for their owner. (Courtesy Bowers Museum of Cultural Art.)

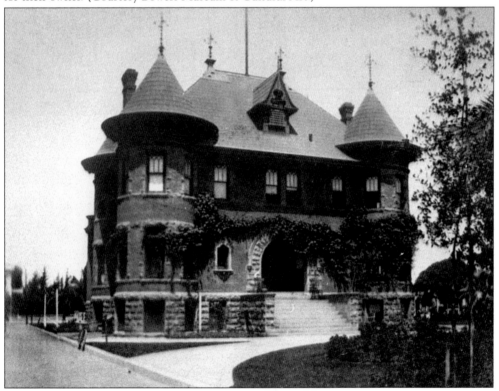

The first Orange County jail building, located on Sycamore Street in Santa Ana, had three cells. Construction began on the Victorian-style building in 1895.

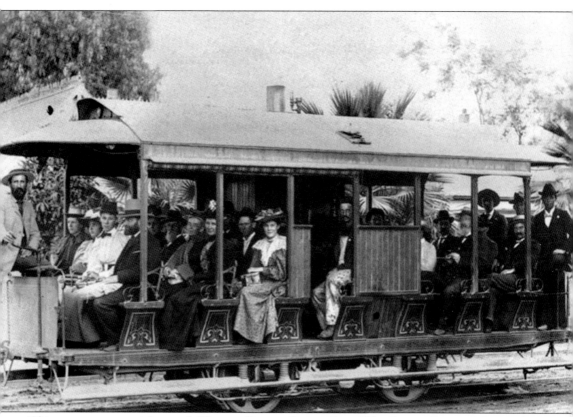

This streetcar was nicknamed "Orange Dummy," as well as "The Peanut Roaster." Powered by a steam boiler and crude oil, it took visiting notables on city tours. Historic accounts include stories of how the trolley filled the air with black smoke that often covered the distance of an entire city street.

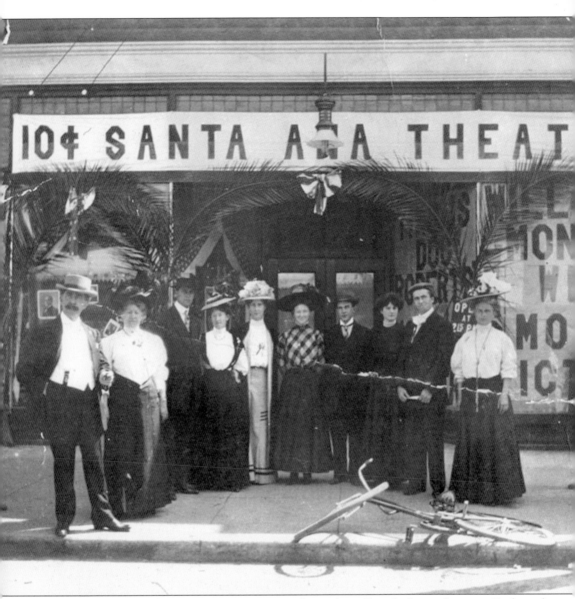

Santa Ana's first motion picture theater was located on Fourth Street between Bush and Spurgeon Streets. This 1907 photograph of moviegoers includes "Doc" A. M. Roberts and his wife, on the far left. (Courtesy Orange County Historical Society.)

Three

1900–1919

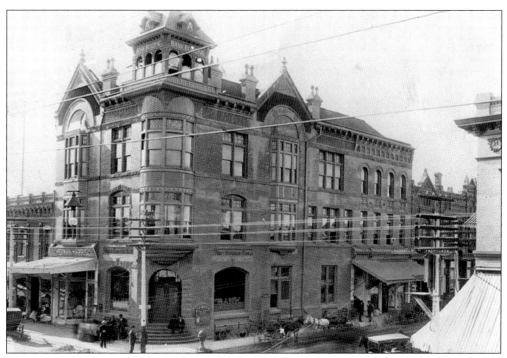

The impressive three-story First National Bank Building was constructed in late 1889 of brick. The building cost $45,000 to build and was located on Fourth Street. In 1923, the bank moved into a new building and in 1926, after an extensive remodel, this building became the Otis Building. (Courtesy Bowers Museum of Cultural Art.)

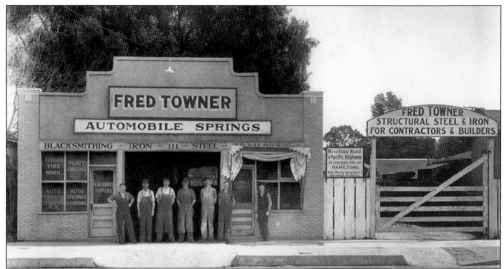

Fred Towner owned the Fred Towner Automobile Springs business and gained a reputation as a blacksmith and repairman for farm equipment. As cars became popular, he also provided auto repairs. Towner applied for several U.S. patents. He was grandson to James W. Towner, who came to Santa Ana in 1882 and was appointed the first judge of the Superior Court after Orange County was created. There is a street in Santa Ana that carries the Towner name. (Courtesy Bowers Museum of Cultural Art.)

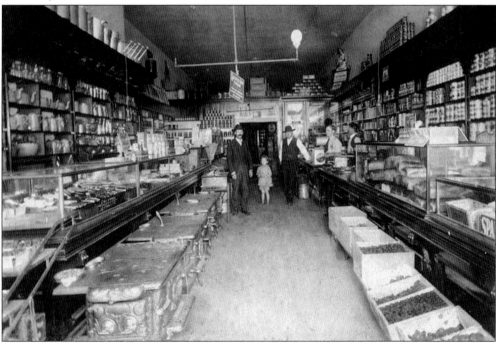

This is a typical store at the beginning of the 1900s. The early shops were like small department stores with all the necessary items for sale. On the left of the photograph are new wood-burning stoves, ready to be purchased. The photograph also shows coffee pots, pans, canning jars, and a variety of food items. The unidentified men in the rear of the store appear to be sales clerks and customers. (Courtesy Bowers Museum of Cultural Art.)

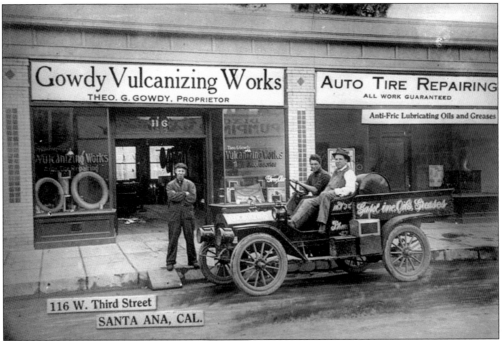

This is the Gowdy Vulcanizing Works, which specialized in automobile and tire repair. Vulcanizing was a process used to harden rubber by heating it with sulphur or sulphur compounds. Gowdy's was located at 116 West Third Street. A 1914 bond measure gave approval for the improvement of 108 miles of roads in the new and growing Orange County. These unidentified men are on the paving truck. (Courtesy Bowers Museum of Cultural Art.)

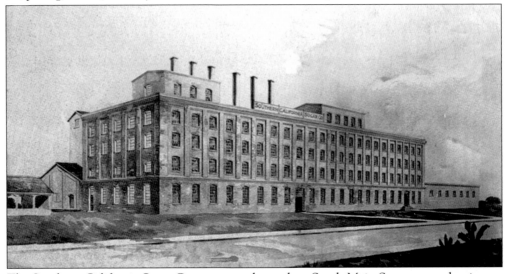

The Southern California Sugar Company was located on South Main Street near what is now Warner Avenue. In 1915, Warner Avenue was known as Delhi. There were two well-known sugar factories in Santa Ana. Just after the beginning of the 20th century, one of Santa Ana's nicknames was "The Sugar City." The annual production of sugar beets in 1912 amounted to $7 million. This building is still used as a location for a commercial retail business. (Courtesy Bowers Museum of Cultural Art.)

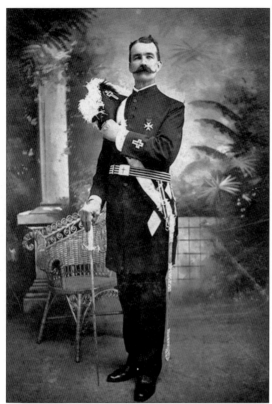

An unidentified man poses in a full-dress uniform associated with the Knights Templar. The Knights were a part of the Masons. (Courtesy Bowers Museum of Cultural Art.)

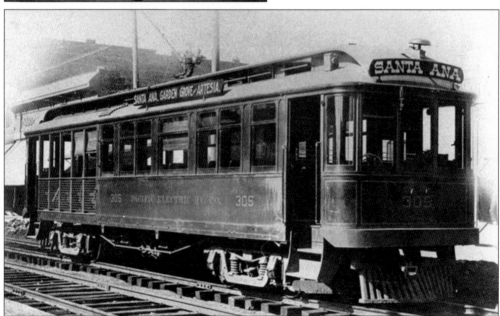

The first Red Car service that linked Santa Ana to other cities began in 1905 and followed the same route established by earlier horse-drawn trolleys. This photograph shows the arrival of the Red Car in Santa Ana after a trip to Watts, Artesia, and Garden Grove. (Courtesy Bowers Museum of Cultural Art.)

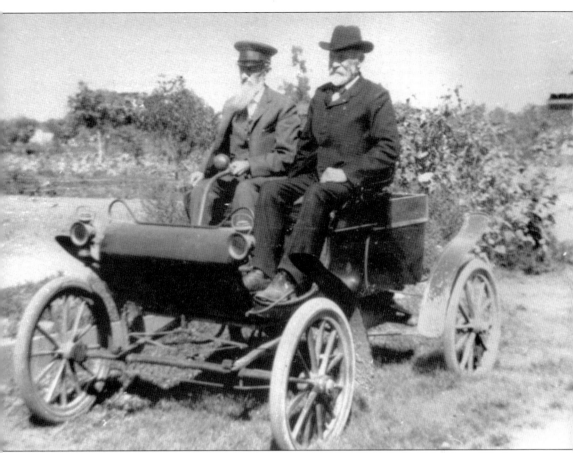

In 1900, there were only three cars in Orange County. In 1901, the Olds Motor Works in Detroit, Michigan, began mass production on the Oldsmobile, a low-cost gasoline car; 425 cars were built. They cost $650 each. By 1905, because of the popularity of the car, 6,500 cars were produced. Two unidentified men enjoy a ride in their merry Oldsmobile. The man on the right bears a resemblance to Judge James Towner.

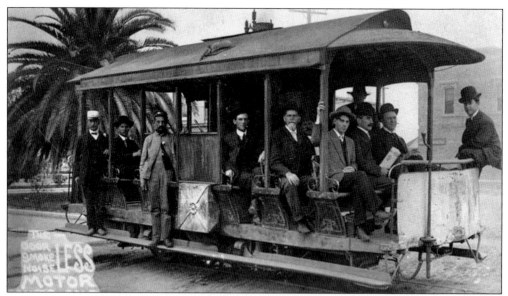

By 1906, public transportation was well developed in Santa Ana. The train had routes from the East Coast to the West Coast, stopping in Santa Ana en route to Los Angeles. The trolleys followed the routes of the earlier horse-drawn trolleys. Routes went into Tustin, Orange, and Fairview, which later became known as Costa Mesa. Each day, nearly 41 trains or trolleys arrived or departed from Santa Ana. (Courtesy Bowers Museum of Cultural Art.)

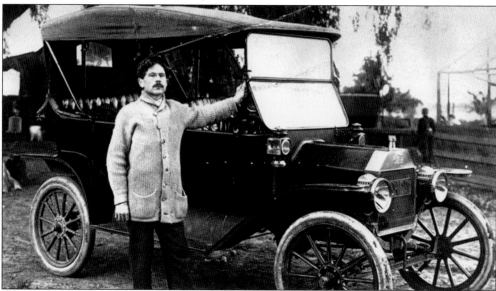

Edward Cochem grew up in Chicago and moved to Santa Ana in 1915, where he lived with his wife and family. He took up photography as a hobby for relaxation, but it eventually became his occupation. His first photography studio was located on West Fourth Street. He became active in many civic organizations and started an association for photographers. He taught photography for five years in adult education classes that were held at Lathrop Junior High School in Santa Ana. He died in the late 1940s. His daughter Adeline carried on his civic interests by founding the Santa Ana Historical Preservation Society in 1974 while saving the Dr. Willella Howe-Waffle House from demolition.

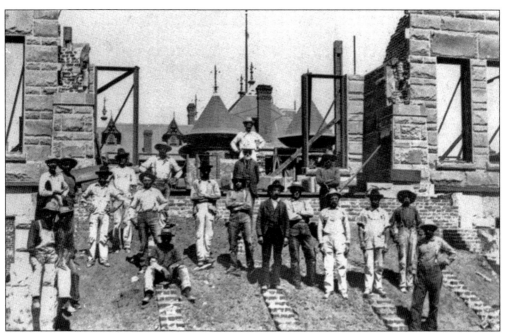

Workers take a break during construction of the courthouse. When Santa Ana was selected as the county seat of the newly formed Orange County, founder William Spurgeon sold a parcel of land to the county with a stipulation that within 10 years, a courthouse be built. The courthouse was constructed from 1900 to 1901.

On November 12, 1901, the historic Orange County Courthouse was dedicated. Designed by Los Angeles architect C. L. Strange in the Richardsonian Romanesque style, a traditional courthouse style for the time, it is one of the few remaining examples of this type of architecture in the state of California. It was designated to the National Register of Historic Places in 1987 and is California State Historic Landmark No. 837.

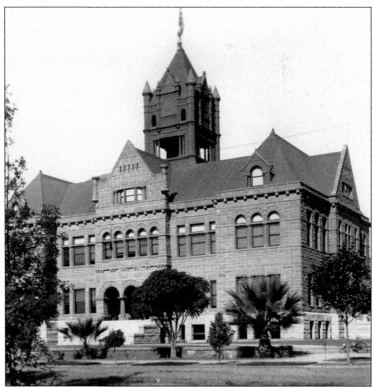

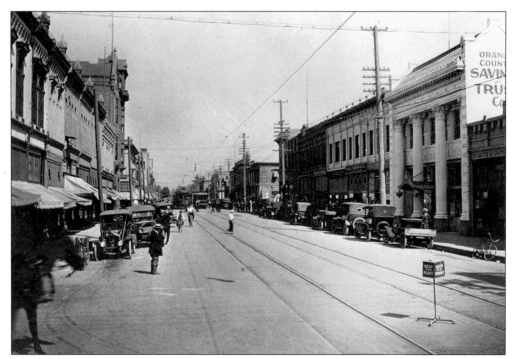

This photograph, near Fourth and Main Streets, shows the Orange County Savings and Trust, built in 1911, on the right. The neoclassical design of the building had very prominent columns. A man on the left side of the street stops to light a cigarette, and a sign in the center of the street warns drivers to "keep to the right." (Courtesy Bowers Museum of Cultural Art.)

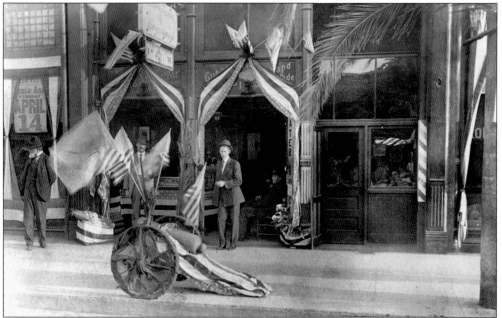

These men stand outside a tobacco shop, with a sign for cigars, and a barbershop (right). Decorative patriotic bunting suggests a town celebration. (Courtesy Bowers Museum of Cultural Art.)

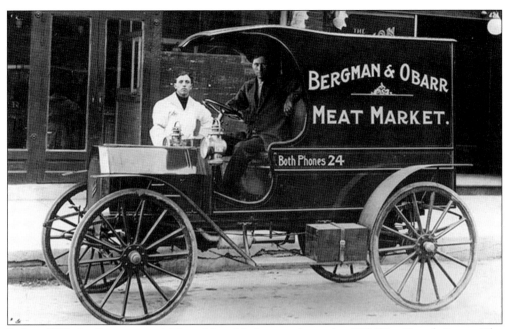

Before 1915, the Bergman and Obarr Meat Market was located at 223 West Fourth Street. The floors of the building above the meat market were used as apartments. After the Depression, the location became a clothing store and the upstairs area was converted into office space. (Courtesy Bowers Museum of Cultural Art.)

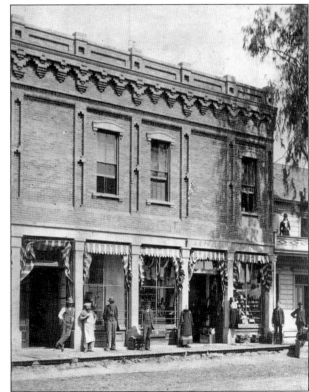

These unidentified men stand outside the Phillips Store on the corner of West Fourth Street and North Broadway. This building stood on the Phillips Block. (Courtesy Bowers Museum of Cultural Art.)

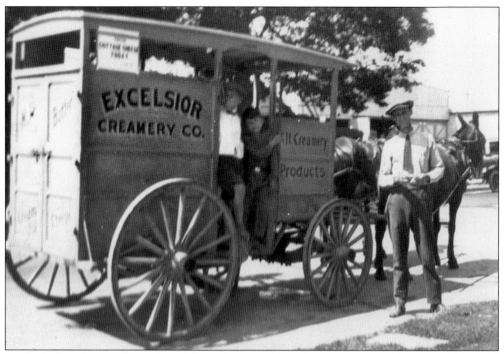

In the early 1900s, milk was not able to be delivered to long distances because of the lack of modern refrigeration and transportation. Milk was bottled at local farms and delivered door-to-door to homes and local stores. This is a photograph of the Excelsior Creamery Company milk delivery truck.

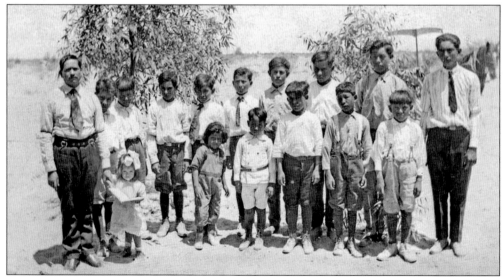

Even before a church was built for the Logan barrio residents, laypersons undertook the religious instruction and provided "dotrina (doctrine) classes" to children in the neighborhood. On the right, the tallest boy is Luis Parga, later the father of Helen Parga Moraga. Ms. Moraga was told the photograph was taken on Lincoln and Stafford Streets. A horse-drawn buggy with a surrey on top is in the background of what was then wide-open spaces, c. 1918. (Courtesy Helen P. Moraga.)

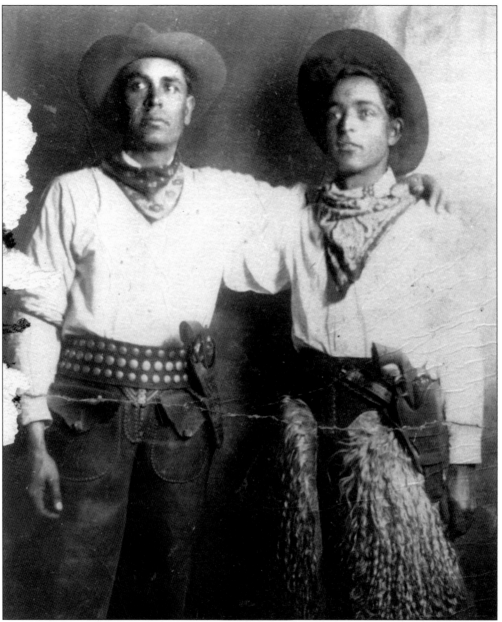

This *c.* 1915 photograph of Francisco Villalobos (right) with his best pal, Manuel (last name unknown), shows the young men wearing the traditional *vaquero* wear from an earlier time. Villalobos, born in 1892, settled with his family in the Delhi area of Santa Ana in 1905 after migrating from Mexico to Los Angeles and then to Santa Ana. In 1917, he married Fernanda Calderon. They had 11 children. Villalobos, respectfully known as "Don Francisco," lived until 1988; he was 96 years old. Until the very end of his life, he could be seen walking the streets of Santa Ana with his last best pal, his dog Tuffy. Five generations survive him. (Courtesy Harvey Reyes.)

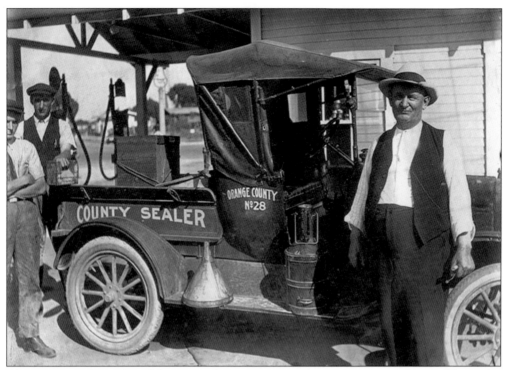

The county sealer enforced honest and accurate measurements with merchants. The sealer would make unscheduled visits to retail businesses and conduct tests to ensure that the weights and measurements used by merchants were accurate and that the customers received their fair share when they made purchases. (Courtesy Bowers Museum of Cultural Art.)

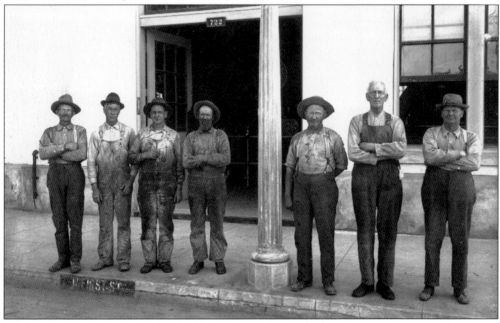

Workmen pose in front of this building at 722 First Street. (Courtesy Bowers Museum of Cultural Art.)

On July 4, 1900, there was a big celebration with a parade, floats, and marching bands. To add the finishing touches to the holiday, balloonist Emil Markeberg came to Santa Ana from San Francisco, where he was well known for his balloon shows. Something went wrong during his descent that caused him to drop rapidly and crash to the ground. The tragic accident took his life. (Courtesy Bowers Museum of Cultural Art.)

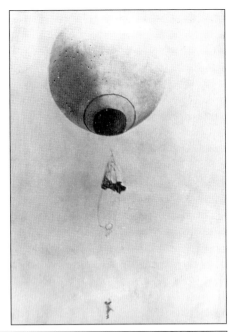

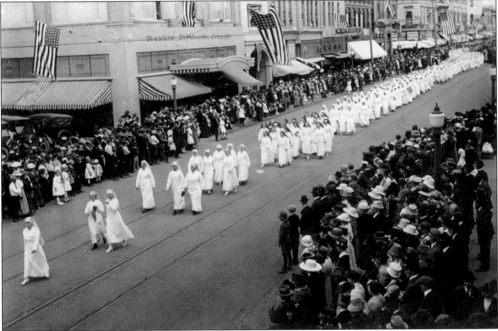

Red Cross nurses are seen marching in Santa Ana to celebrate the end of World War I. During the war, these nurses helped doctors with the injured—both military and civilians. In the United States, the nurses helped setup programs for returning soldiers and their families. More than 29,000 nurses were recruited during World War I. These volunteer recruits became known as the "Grey Ladies" because of the color of their uniform. The Red Cross nurses were valuable in helping with the outbreak of the Spanish influenza, which started in Europe and spread to the United States, killing over 22 million between 1918 and 1919. (Courtesy Bowers Museum of Cultural Art.)

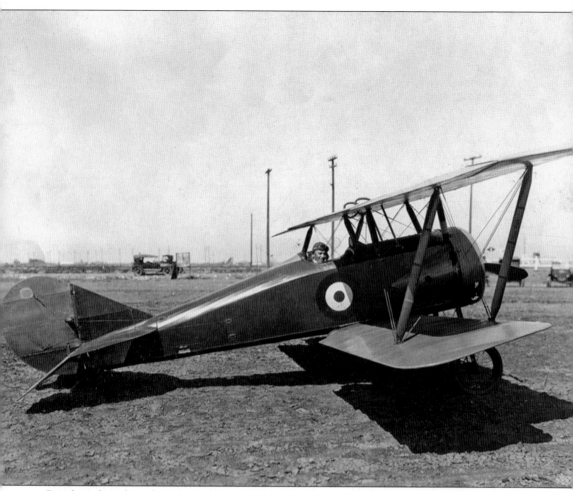

People gathered at a large pasture owned by McFadden to watch Glenn Martin fly. After several unsuccessful attempts, the plane took off into the air as the crowd of admirers cheered. (Courtesy Bowers Museum of Cultural Art.)

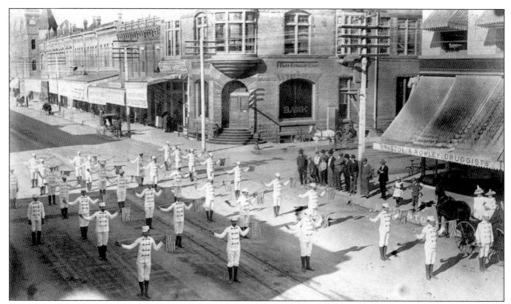

Started in 1905, the Carnival of Products Parade was an annual event with floats and marching bands. The parade's first year was so successful that, in the following years, it became a three-day event. This parade, photographed around 1910, is on Fourth street, with the Columbia Marching Club performing.

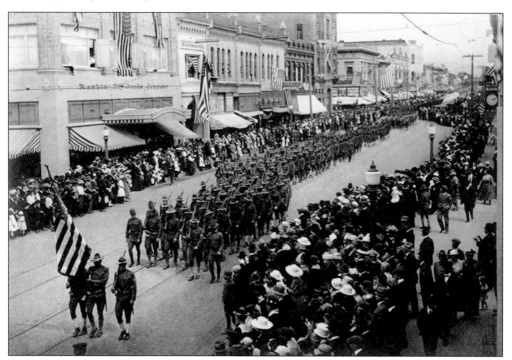

With a peace treaty signed on November 11, 1918, signaling the end of World War I, the feeling of patriotism was high in America. The citizens of Santa Ana stood outside and cheered as the troops were welcomed home. Rankin Dry Goods Store is pictured on the left in this photograph. (Courtesy Bowers Museum of Cultural Art.)

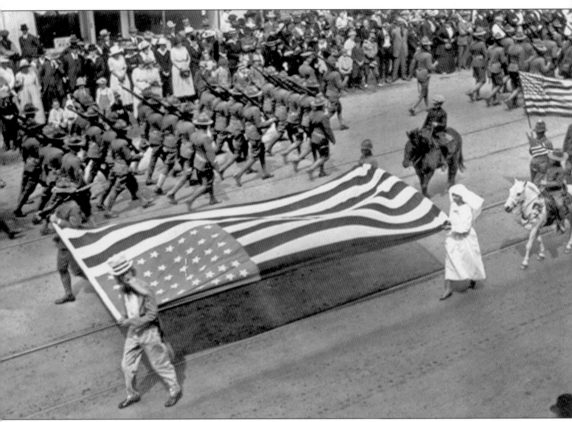

A Red Cross nurse and Uncle Sam are carrying the American flag, assisted by returning soldiers. In 1918, Santa Ana marked the end of World War I with this celebratory parade. (Courtesy Bowers Museum of Cultural Art.)

Franklina Gray Bartlett was the wife of William Bartlett, a prominent banker in Santa Ana. From 1894–1897, she was the first president of the Ebell Society of Santa Ana Valley. She was born in 1854 and died in 1934.

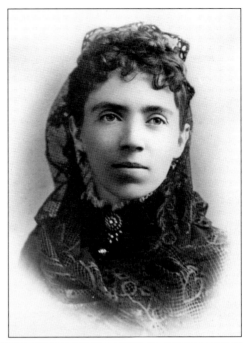

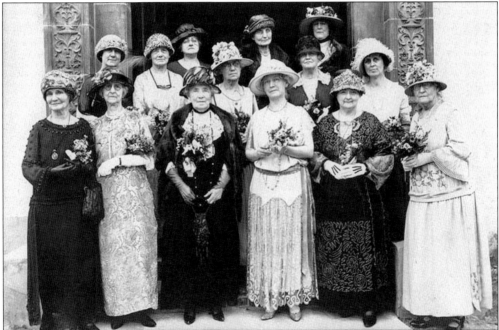

These ladies were members of the Ebell Society, which dates back to 1894. This women's organization was comprised of elite ladies who had compassion for others. The purpose of the organization was to foster education as well as social and cultural growth in the community. Women in the Ebell Society actively lobbied for a woman's right to vote and access to education for women. This philanthropic organization is still active in Santa Ana and many other communities. The Ebell Clubhouse, located at 625 French Street, is still used for gatherings. (Courtesy Bowers Museum of Cultural Art.)

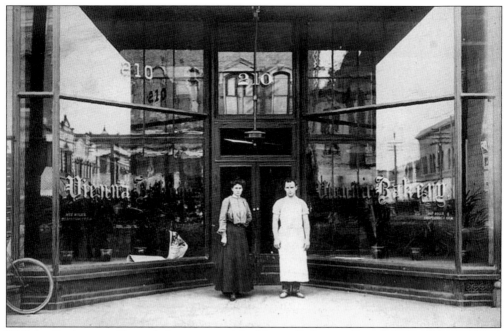

William Cochems and his wife, Jessie, owned the Vienna Bakery on Fourth Street. The Cochems family can trace their roots back to Germany. William died in 1933 at the age of 59 and Jessie died in 1961 at the age of 71. William was related to noted Santa Ana photographer Edward Cochems. (Courtesy Bowers Museum of Cultural Art.)

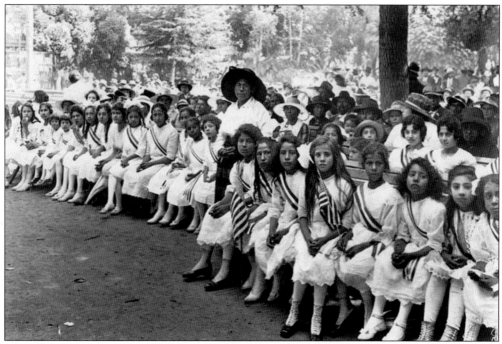

Schoolgirls sit attentively at this early 1900s outdoor event. Adults sit in the back rows behind the girls. Each of the girls holds an American flag, indicating that this outdoor event was a patriotic celebration. (Courtesy Bowers Museum of Cultural Art.)

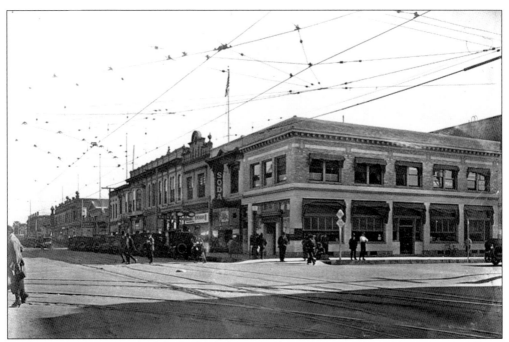

By the 1900s, Santa Ana had the look of a big city. There were a number of shops, hotels, offices, and banks. In 1912, the population of Santa Ana was 12,000. There were six banks with total deposits of $5 million. Three railroads—Pacific Electric, Santa Fe, and Southern Pacific—all had routes through Santa Ana. On the left of the photograph is the Rossmore Hotel, which was located at Fourth and Sycamore. Electric wires for the trolley car run along the center of the street. (Courtesy Bowers Museum of Cultural Art.)

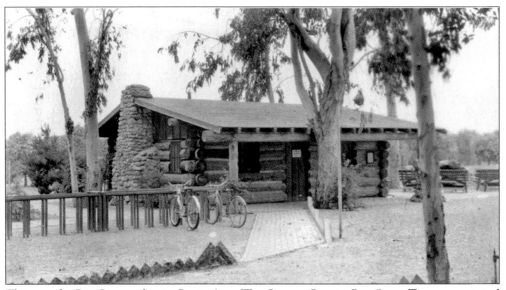

This was the Boy Scout cabin in Santa Ana. The Orange County Boy Scout Troop was started in 1917. (Courtesy Bowers Museum of Cultural Art.)

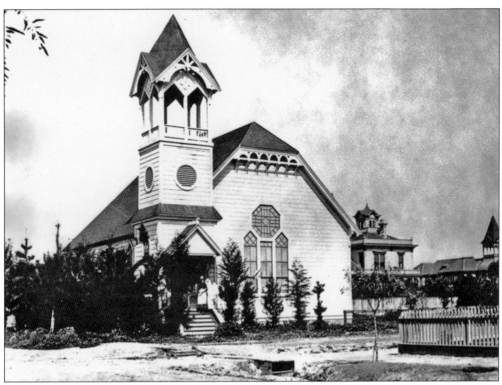

The First Christian Church, c. 1900, was located on the northeast corner of Sixth and Birch Streets. Prior to having this building, the congregation held services in the old schoolhouse, sharing the space with the Methodists and the Baptists. The building was demolished, and the site is now home to the Orange County Hall of Administration. A number of years ago, Sixth Street was renamed Santa Ana Boulevard.

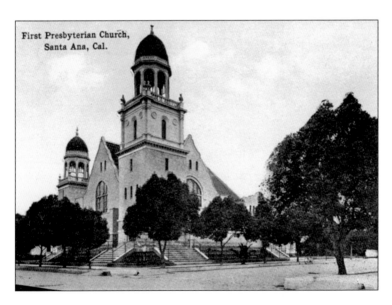

Built in 1900, the First Presbyterian Church, pictured here in 1915, had a facade added in 1937. It is styled in a late Gothic Revival design. Before his death, aviator Glenn Martin (1886–1955) was responsible for donating to the remodel and restoration of the church, located at Sycamore and Santa Ana Boulevard.

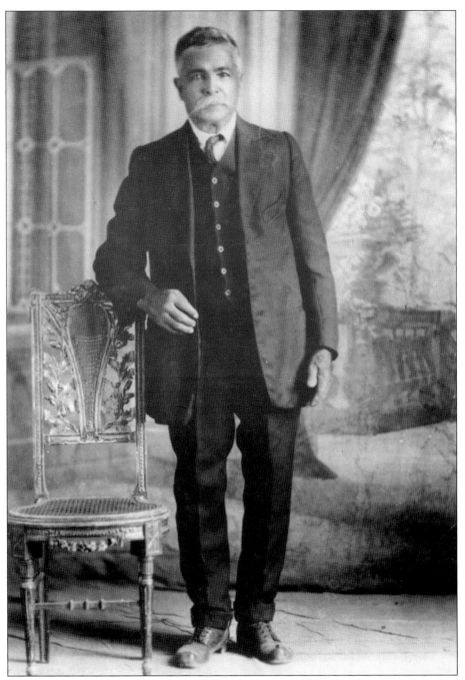

This studio photograph shows Ambrosio Villalobos around 1910. Villalobos was born in 1860, married Timotea Munoz, and traveled to and from Mexico through most of the late 1800s, wherever jobs were available. After one migration from Mexico, he moved first to Los Angeles, and then settled with his family in 1905 in the Delhi neighborhood. After a separation from his wife and family in the 1910s, he moved on, presumably back to Mexico. His wife, Timotea, and their offspring continued to live in Delhi. Timotea died in 1955, and the surviving family members continue to live in the area. (Courtesy Harvey Reyes.)

This is Spurgeon Memorial Methodist Church as it looked in 1915. Though the church was established in 1870, this building was not constructed until 1906. It was located at the corner of Broadway and Church Streets. In recent years, Church Street was renamed Eighth Street.

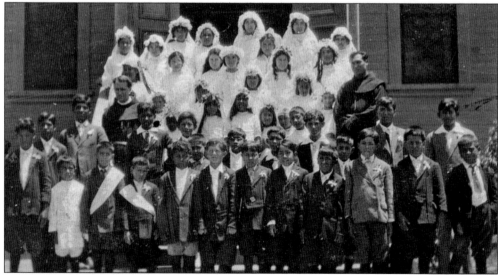

Children from the historic Logan barrio pose for a Holy Communion photograph on the front steps of St. Joseph's Catholic Church around 1913. Early residents of the Logan barrio worshiped at the "little church near the depot," as St. Joseph's Church was called then. St. Joseph's Catholic Church was built on land bought by Bishop Mora from the Western Development Company. The company wished to promote Santa Ana East as a commercial hub of Santa Ana. The Logan residents later held fund-raisers within the Mexican community to build their own Our Lady of Guadalupe Catholic Church on Third Street. This church has been rebuilt in recent years, but it still is a vital part of the community in Eastern Santa Ana. (Courtesy Mary Garcia.)

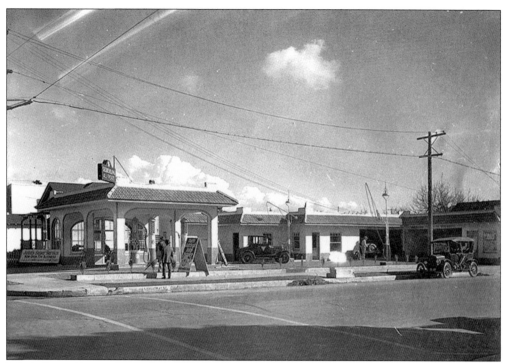

John's Super Service Station and garage is pictured here in the early 1900s, with a uniformed attendant near the garage. (Courtesy Bowers Museum of Cultural Art.)

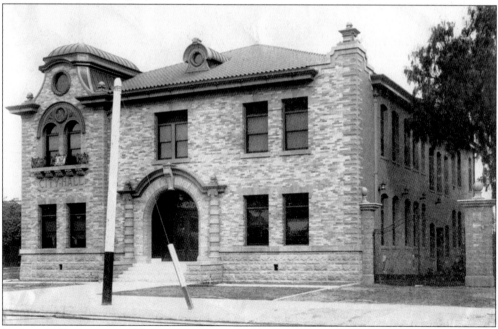

Built in 1903, the original Santa Ana City Hall was located at the southeast corner of Third and Main Streets. Unfortunately the building was severely damaged as a result of the earthquake that struck Long Beach in 1933. A few years after the earthquake, the building had to be demolished. (Courtesy Bowers Museum of Cultural Art.)

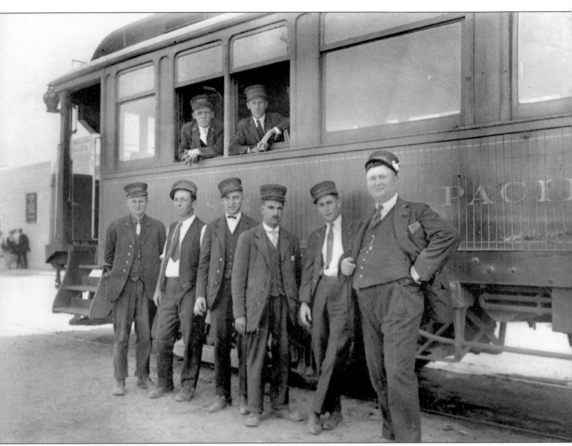

This 1906 photograph shows the crew of the first Pacific Electric Railway as it entered the depot in Santa Ana. Train conductors were responsible for the safety and schedule of the entire train and walked the entire length of the train to oversee passengers and crew. They helped when trains broke down, they collected tickets, and they assisted passengers. (Courtesy Bowers Museum of Cultural Art.)

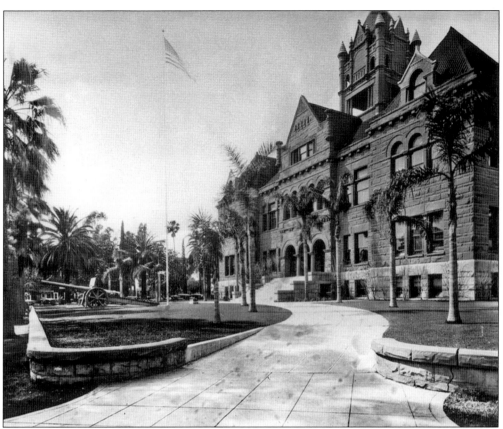

The landmark old Orange County Courthouse was constructed of Arizona red sandstone. This historic courthouse was the sight of many far-reaching decisions, including the Whipstock case, which dealt with slant oil drilling and interpretation of the farm labor law, and the Overell Trial that resulted in a law regulating explosives.

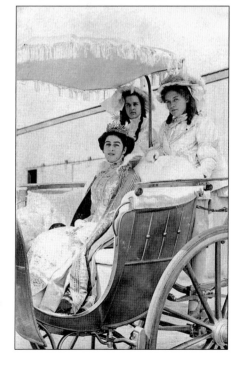

In 1906, being selected queen of the Carnival of Products was an honor similar to being the queen of a modern-day beauty contest like the Rose Parade. The lovely ladies who earned the titles of queen and her princesses rode in the parade for the Carnival of Products. N. A. Ulm was responsible for the success of this annual parade, which ended after Ulm passed away.

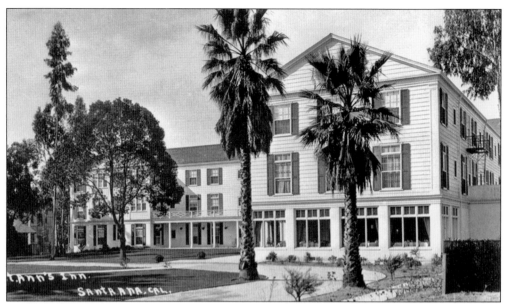

St. Ann's Inn was once a popular resort frequented by Hollywood stars who wanted to escape the limelight. There were rumors that several stars were married in private nuptials at the Santa Ana Courthouse to avoid publicity, then checked into the inn. Located on Broadway between Sixth and Seventh Streets across from the old Orange County Courthouse, the facility was used as an annex to the courthouse for a brief period of time.

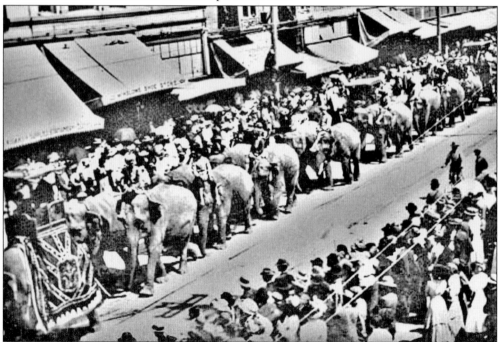

The Ringling Brothers Barnum and Bailey Circus is parading on Fourth Street. It was a thrilling event when the circus came to town, and it gave the local people an opportunity to see clowns, elephants, lion tamers, and acrobats. In 1905, 1908, and 1910, the circus came to Santa Ana in late September.

Four

1920s

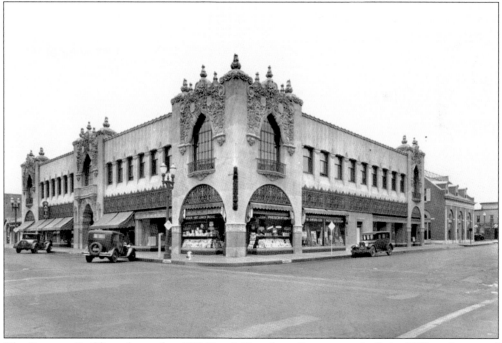

The Santora Building, located at 207 North Broadway Street, was built in 1929 and restored in the 1980s. This distinctive building was commissioned to be a landmark structure by Oliver Halsell, vice president of the Santora Land Company. The building was constructed of poured concrete in the Churrigueresque style, one that reflects the 17th- and 18th-century Spanish baroque style found in many Spanish cathedrals. In the ornate details are gargoyles and demons. This building is the central gem in the newly built artist village section of Santa Ana. (Courtesy Bowers Museum of Cultural Art.)

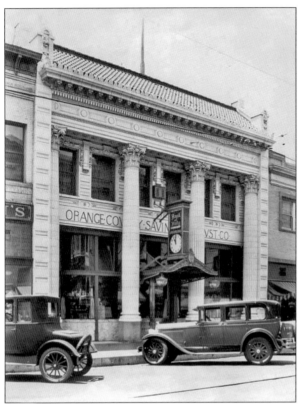

The Orange County Savings and Trust Company, located at 116 West Fourth Street, was designed in a neoclassical style that featured two large columns near the front door of the bank. By 1912, the bank had cash reserves in excess of $300,000. The building still exists but has been altered and does not have the same appearance. (Courtesy Bowers Museum of Cultural Art.)

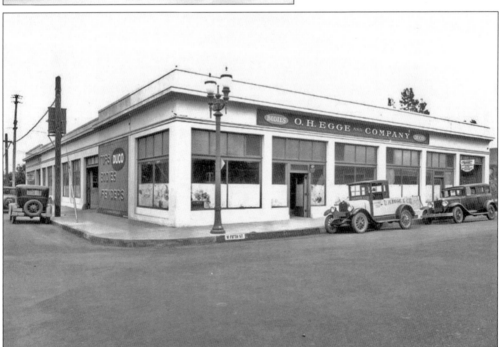

O. H. Egge and Company was located on West Fifth Street in Santa Ana. The shop provided automobile repairs for tops, bodies, and fenders. (Courtesy Bowers Museum of Cultural Art.)

Breakfast Club of Santa Ana, Calif. (date) 9-24

Membership Application Card

I hereby apply for membership in the Breakfast Club. In consideration of admittance thereto, I pledge myself to abide by its By-Laws, Rules, Edicts and Regulations. I shall be faithful in attendance and to the Club. I will pay my dues promptly— and will serve in every way possible for the good of the Club.

Therefore, and in consideration of the membership fee, herewith paid, receipt of which is hereby acknowledged, I shall be entitled to all the privileges, benefits and functions of the Santa Ana Breakfast Club.

Applicant's Signature *Hale T. Barker* Membership Fee 1⁰⁰ Dues

Address *2000 S. Birch* Phone *3875-J* Membership Certificate _____ Cap Size 7

Approved: _____ Monthly Card _____ Birthday *Nov. 17*

The Santa Ana Breakfast Club was established in 1925 by a group of businessmen. The club became well known for the large outdoor breakfasts that were held for its members and guests. (Courtesy Bowers Museum of Cultural Art.)

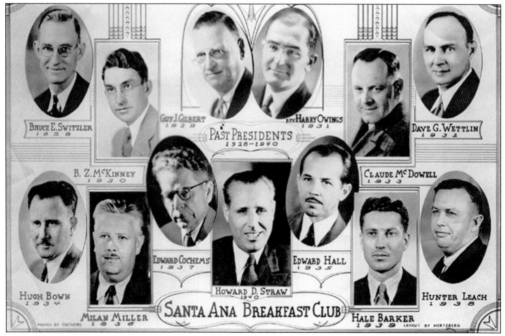

This photograph honors the past presidents of the Santa Ana Breakfast Club, ranging from 1929 to 1940. The club met informally from 1925–1928 and then actively sought new members. In Santa Ana during the 1920s, it was very popular to join clubs and organizations. (Courtesy Bowers Museum of Cultural Art.)

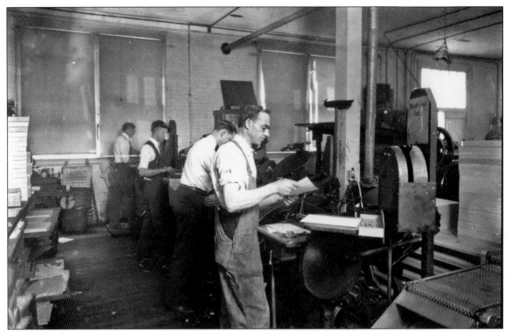

These men are working the printing presses of the *Santa Ana Herald*, the first newspaper printed in the city in 1878. Through the years, it has undergone several name changes and has been physically moved to different locations within the city. In the 1970s, the paper became known as the *Orange County Register*. (Courtesy Bowers Museum of Cultural Art.)

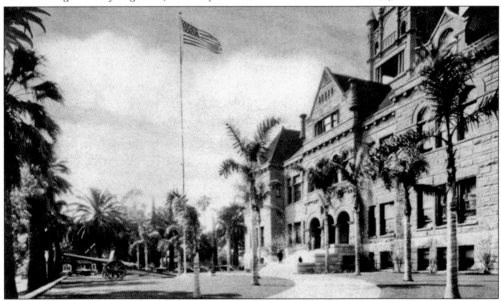

This is a photograph of the courthouse as it looked in 1920s. The Orange County Courthouse is the oldest one still in existence in Southern California. Building costs were $117,000. The building suffered some damage in the earthquake of 1933. In 1968, a new courthouse was built and the original one closed. In 1987, restoration began on the old building and was completed in 1992. The old courthouse is now a museum with displays of early Santa Ana history. It is located in downtown Santa Ana between Sycamore and Broadway Streets.

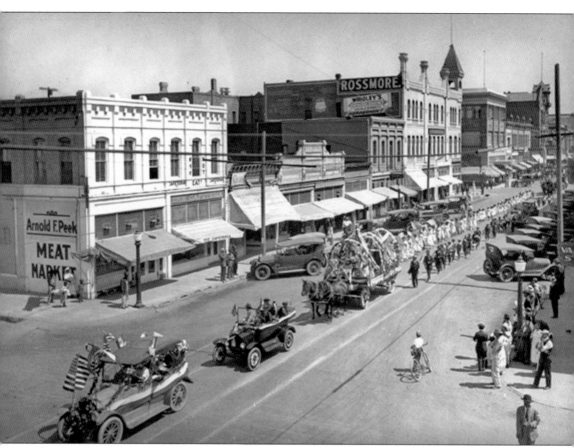

This parade came down Fourth Street in the 1920s. On the right of the photograph is the Hayes Variety Store. On the left, in the distance, is the Rossmore Hotel. Most of the Rossmore was destroyed in the 1933 earthquake. (Courtesy Bowers Museum of Cultural Art.)

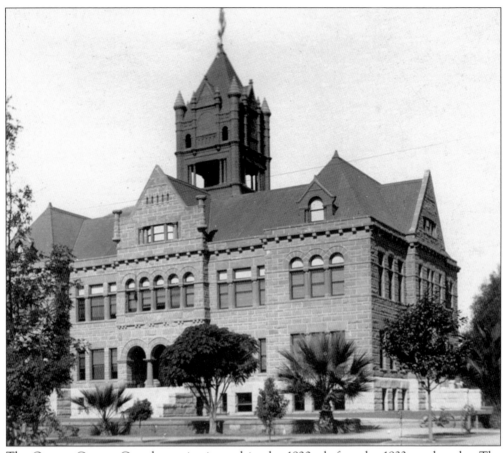

The Orange County Courthouse is pictured in the 1920s, before the 1933 earthquake. The tower on top of the courthouse was later removed due to earthquake damage. The contractors for this original building were Chris McNeill and J. Willis Blee.

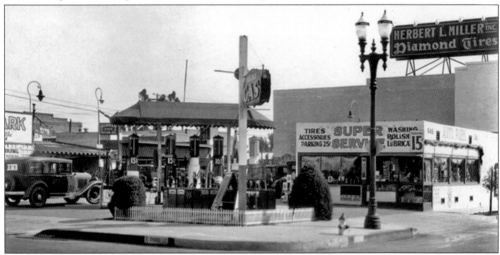

The Herbert L. Miller Diamond Tires store was next to a large corner gas station. The prices at the pump were 10¢ and 15¢ a gallon. (Courtesy Bowers Museum of Cultural Art.)

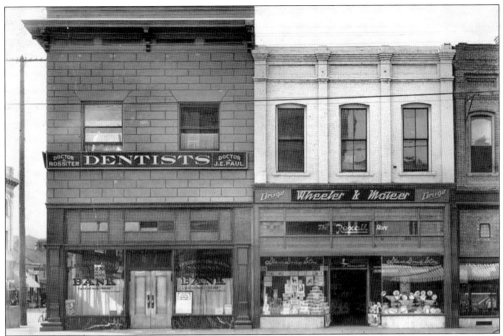

This is a 1920s photograph of the corner of Main and Fourth Streets. The bank is located downstairs, and upstairs is the dental office of Dr. Rossiter and Dr. J. E. Paul. Next door is the Wheeler and Moteer Rexall Drug store. (Courtesy Bowers Museum of Cultural Art.)

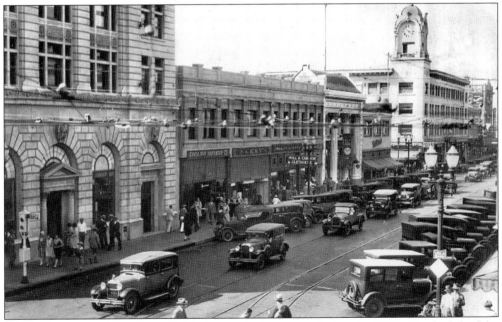

This is the corner of Fourth and Main Streets in downtown during the 1920s. On the left of the photograph near the end of the street is the Spurgeon Building with its tall, ornate clock tower. Just before the Spurgeon Building is the Orange County Savings and Trust. This building is still in use, but the exterior has been slightly changed. Also on the left of the photograph is the corner of the First National Bank Building. (Courtesy Bowers Museum of Cultural Art.)

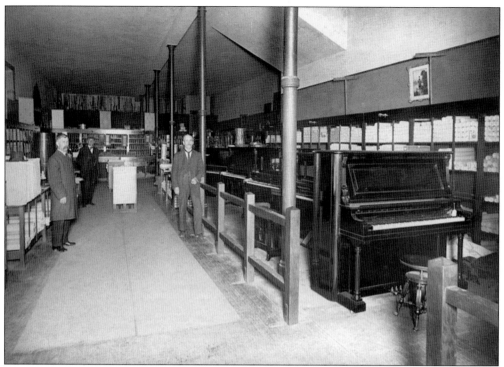

In the beginning of the 20th century, there were no radios, televisions, or computers in the home. Pianos were a popular form of leisure entertainment.

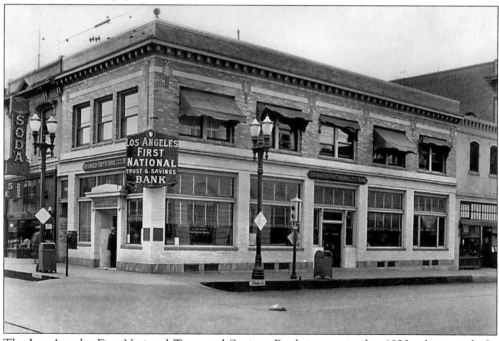

The Los Angeles First National Trust and Savings Bank is seen in this 1920s photograph. In later years, the bank was involved in several mergers and became Security Pacific National Bank and then Bank of America. (Courtesy Bowers Museum of Cultural Art.)

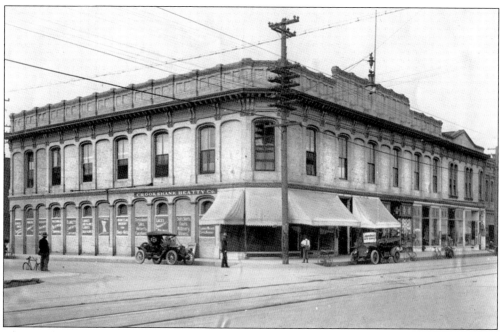

This is the Crookshank and Beatty dry goods store. A. J. Crookshank was a prominent businessman. He entered into a joint venture cooperative with other local businessmen to establish a hotel. He managed the hotel and served as its president. (Courtesy Bowers Museum of Cultural Art.)

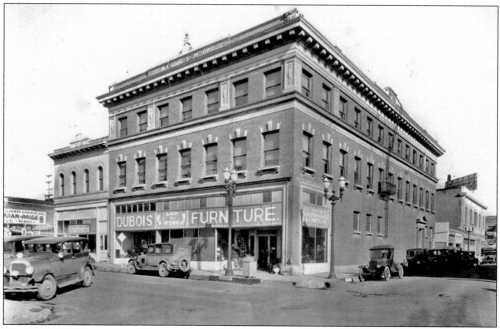

The DuBois Furniture store was located on the ground floor of the three-story Masonic temple. Over the years, the Masonic temple has been redesigned and rebuilt several times. This photograph shows one of the early Masonic buildings. (Courtesy Bowers Museum of Cultural Art.)

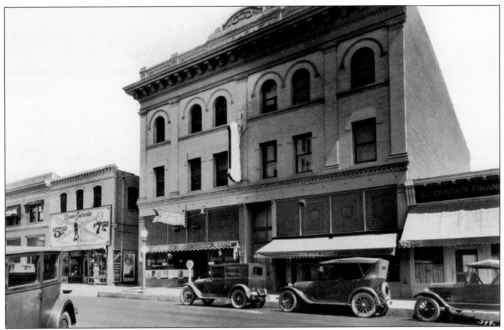

On the right side of the street, between a lunch café and Interstate Financial, is the four-story Odd Fellows building. The three intertwined circles on the top of the building symbolize friendship, love, and truth—qualities that are key to the Odd Fellows fraternity. This building is still located at 309–311 North Main Street. (Courtesy Bowers Museum of Cultural Art.)

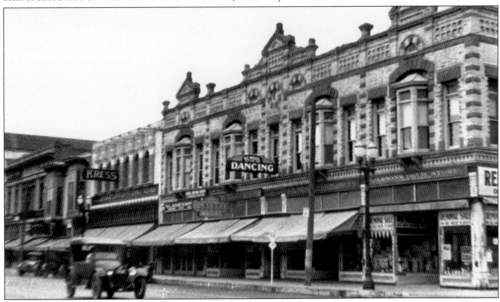

Fourth and Main Streets were in the heart of the shopping district. On the right in the middle of the block is the Kress Variety Store. Kress was known as a dime store that was a cut above the rest. The owner, Samuel H. Kress, was an art collector. Kress made it a practice to include the Kress coat-of-arms in the exterior decor of many of their stores. During this era, dime stores purchased merchandise in large quantities and sold it inexpensively. (Courtesy Bowers Museum of Cultural Art.)

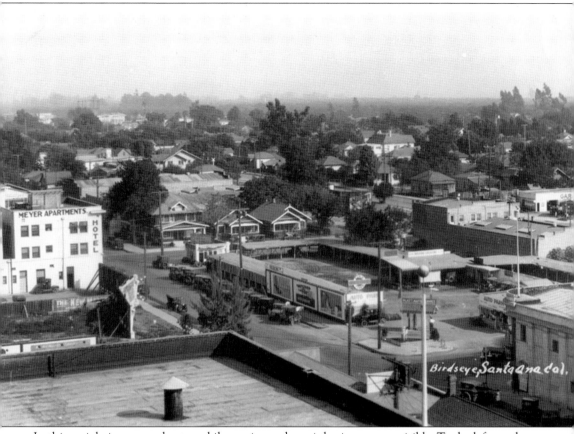

In this aerial view, several automobile service and repair businesses are visible. To the left are the Meyer Apartments, which later became the Corday Hotel, located at 306 Spurgeon Street. A group of California bungalow homes are pictured in the background. (Courtesy Bowers Museum of Cultural Art.)

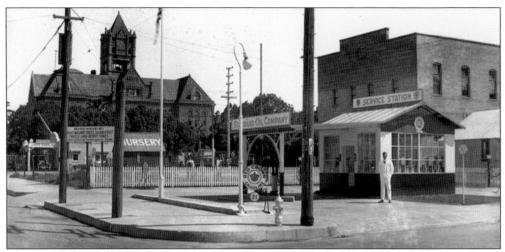

This is a 1920s photograph of a Standard Oil gas station at Fifth and Broadway. A sign in front of the station advertises Red Crown gasoline. Red Crown gasoline was originally designed for aviation use and promoted as a "gasoline of quality." Today Standard Oil Company is better known in California as Chevron Oil Company. Next door to the gas station, a nursery offers walnut trees, other fruit trees, and berries. In the background is the old Orange County Courthouse with its original tower, which was removed after the 1933 earthquake. (Courtesy Bowers Museum of Cultural Art.)

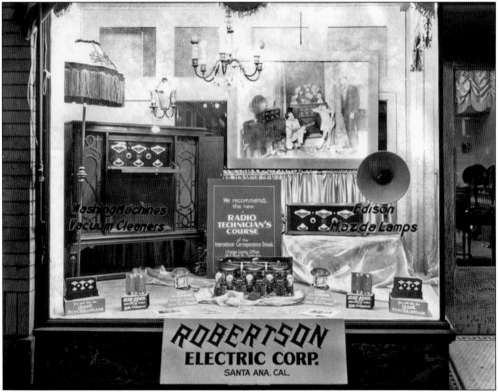

This 1926 photograph shows Robertson Electric, located on Fourth and Main Streets in the center of the business district. (Courtesy Bowers Museum of Cultural Art.)

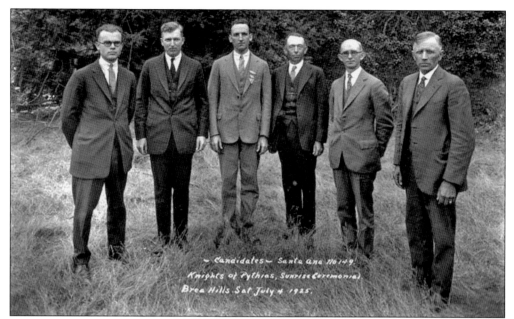

Candidates for the Knights of Pythias met on July 4, 1925, just outside Santa Ana in Brea Hills. These unidentified men attended the sunrise ceremonies. (Courtesy Bowers Museum of Cultural Art.)

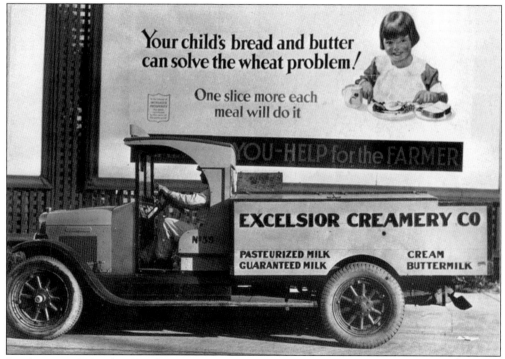

In August 1922, the Excelsior Dairy was located at 926 East First Street. The dairy, established in 1915, was owned by Elmer and Gertrude Burns of Santa Ana and W. L. Russell of Garden Grove. In this photograph, the dairy truck is ready to begin delivering milk products to various homes and businesses.

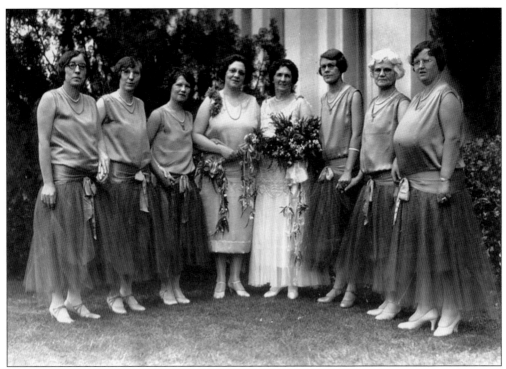

This is believed to be a wedding photograph from the 1920s. The bride and her attendants are unidentified. (Courtesy Bowers Museum of Cultural Art.)

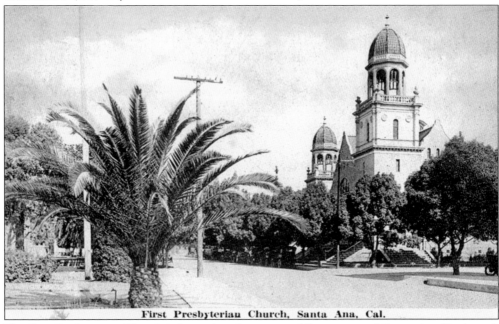

First Presbyterian Church, Santa Ana, Cal.

The First Presbyterian Church is located at the corner of Sycamore and Santa Ana Boulevard. Built in 1906 with late Gothic Revival influence, the building is also used by Santa Ana arts organizations. Students from the Orange County Performing Arts High School use the large auditorium, which is now called McFarland Hall, for rehearsals and performances.

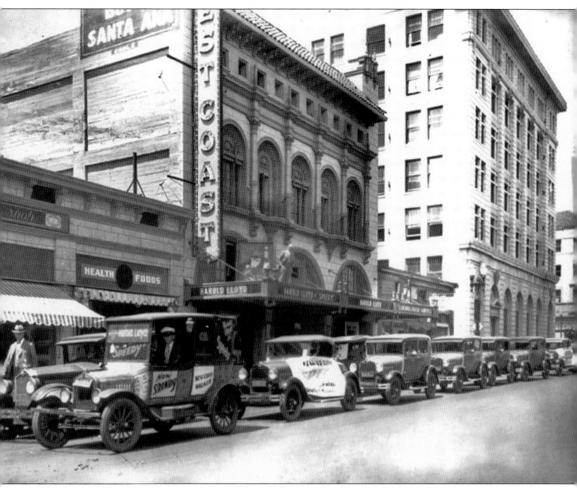

The Skouras brothers managed the Walker Theater as well as several other theater chains. After the brothers took over, the interior style of the theater was described as "Skouras-ized for Showmanship." They hired designer Carl G. Moeller to give the theater a streamlined Art Moderne look. It eventually became the Fox West Coast Theater. In 1950, the theater was purchased from Walker by Lewis Olivos and his family. The theater was closed for several years and was in need of repair. In 1991, the Christian Tabernacle bought it for $750,000 and spent a large amount on repairs. The building is still used as a church and reflects an early time in Santa Ana's past. In this 1928 photograph, the marquee advertises Harold Lloyd staring in *Speedy*. (Courtesy Bowers Museum of Cultural Art.)

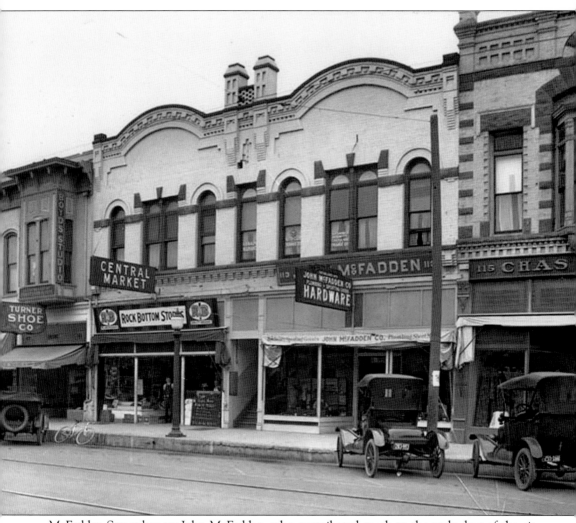

McFadden Street honors John McFadden, who contributed much to the early days of the city. During the 1870s, he and his brother moved to Santa Ana. John established this hardware store on Fourth Street. His son E. T. McFadden took over the business and formed a partnership with H. H. Dale in 1926 to carry on the tradition of service and quality that was started by the store's founder. (Courtesy Bowers Museum of Cultural Art.)

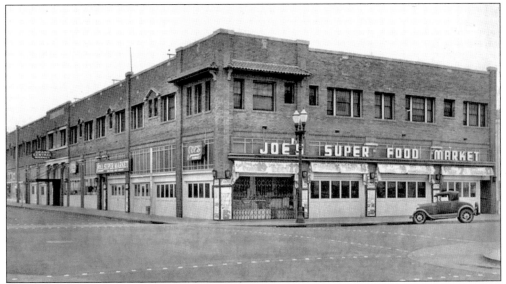

Joe's Super Food Market was part of the Grand Central Market. Built in 1924, the market complex, located at Second and Broadway Streets, included several commercial businesses. The building, now known as the Grand Central Art Center, has been refurbished and is part of the Artists Village Redevelopment Area in downtown Santa Ana. California State University Fullerton uses the space for extension classes. Steven Ehrlich Architects served as the design architect for the refurbished project with Robbins Jorgensen Christopher Architects as the executive architect. (Courtesy Bowers Museum of Cultural Art.)

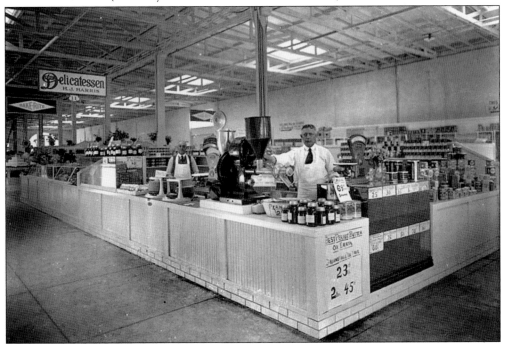

Two clerks are ready for customers at the H. J. Delicatessen. A sign in the front of the store advertises peanut butter—"Best Peanut Butter on Earth, creamed while you wait." The peanut butter sold for 23¢ a pound or two pounds for 45¢. (Courtesy Bowers Museum of Cultural Art.)

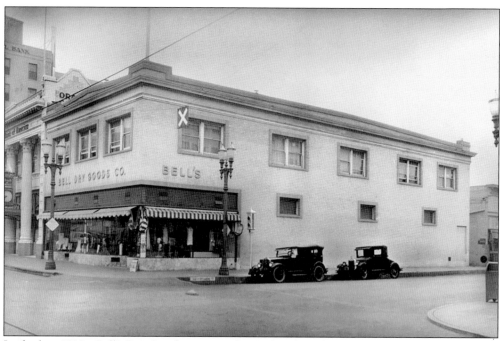

In the late 1920s, Bell's Dry Goods store was located on Fourth and Sycamore. Dry goods stores sold fabrics, threads, and similar non-food items. (Courtesy Bowers Museum of Cultural Art.)

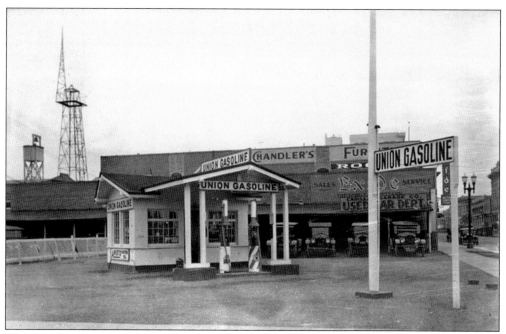

By 1913, there were nearly 123,000 automobiles in California. Union Oil was established in October 1890 with headquarters in Santa Paula, California. The first service station opened in downtown Los Angeles. This Union gas station was located next to Chandler's Furniture store near downtown Santa Ana. By 1925, Union Oil Company owned over 400 service stations along the West Coast. (Courtesy Bowers Museum of Cultural Art.)

In 1886, James T. Raitt moved to Santa Ana. In 1890, he started a dairy business that was named the Raitt Sanitary Dairy. Raitt believed in providing both quality and cleanliness to his customers. When he started the dairy, he personally washed each of his seven cows before milking them to assure cleanliness. In 1927, Raitt and his employees posed for this photograph in front of the dairy's office, which was located at 1008 East Fourth Street. The business was so successful that it was incorporated in 1920 and had shareholders who paid $1,000 per share. Years later, the business was sold to Arden Farms. Raitt Street in Santa Ana was named in honor of this successful dairyman. (Courtesy Bowers Museum of Cultural Art.)

East Fourth Street was home to a variety of businesses, including the Broadway rooming house, Sam Stein's stationery store, and the Singer sewing store. Sam Stein's store was located at 305 Fourth Street and is listed in the Santa Ana register of historical properties. (Courtesy Bowers Museum of Cultural Art.)

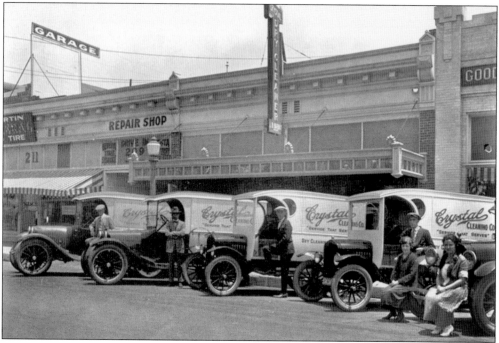

These drivers stand next to delivery vehicles owned by the Crystal Cleaning Company. Through the 1920s, professional laundry companies opened to serve the needs of hotels, restaurants, hospitals, and health care facilities. (Courtesy Bowers Museum of Cultural Art.)

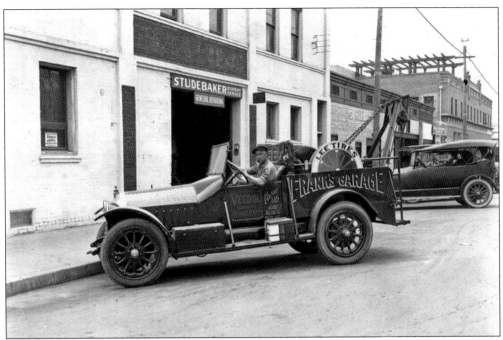

An unidentified man sits in the driver's seat of a tow truck for Frank's Garage. This automobile repair shop featured expert service on Studebakers. Studebakers were built until the early 1960s. (Courtesy Bowers Museum of Cultural Art.)

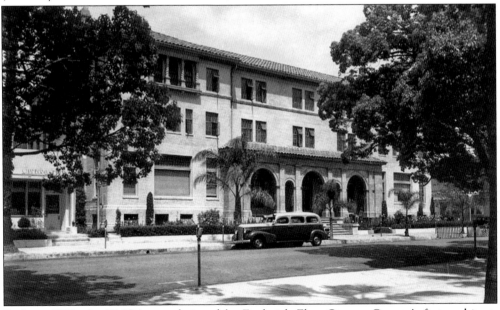

Built in 1923, the YMCA was designed by Frederick Eley, Orange County's first architect. Contributions from the citizens of Santa Ana provided $234,000 to pay for the building costs. The building was designed in the Mediterranean classical style. In October 1924, Dr. Ralph C. Smedley gathered a group of men for a meeting in the basement of the YMCA. The purpose was to practice the art of public speaking. That meeting was the foundation of Toastmasters International.

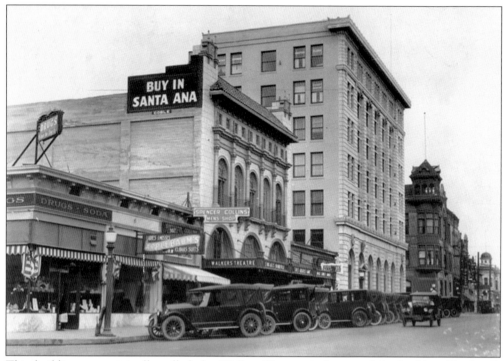

This building was originally called the Walker Theater in honor of the builder, Charles E. Walker. It was located at 308 North Main Street and was designed by architect Carl Boller in the 1920s at a cost of $250,000. (Courtesy Bowers Museum of Cultural Art.)

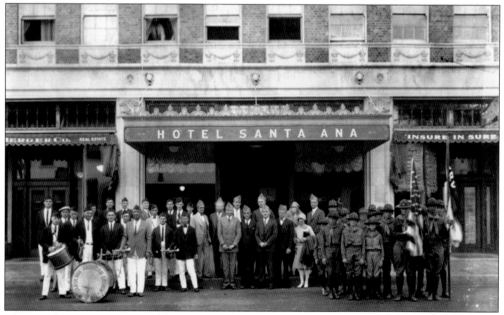

The Hotel Santa Ana was built in 1922 on the corner of Main and Sixth Streets. McCoy's Drug store was located on the ground floor of the hotel. The hotel was torn down in the 1980s and the land became a parking lot. In the photograph, Boy Scouts and members of the American Legion stand in front of the hotel. (Courtesy Bowers Museum of Cultural Art.)

Five

1930s

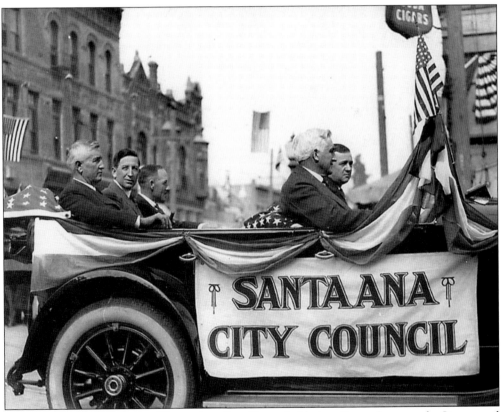

In the 1930s, past members of Santa Ana City Council ride in a Santa Ana parade. Six council members represent residents in each of the city's six wards. A mayor serves the community at large. (Courtesy Bowers Museum of Cultural Art.)

This 1930s view of Third and Main Streets shows the side of Santa Ana City Hall. This building was designed by Austin and Wildman and built by the Honer Company as a WPA project. The city received federal grants to supplement the building costs. In 1974, city offices moved to a new building and this structure was restored and used as commercial office space. (Courtesy Orange County Archives.)

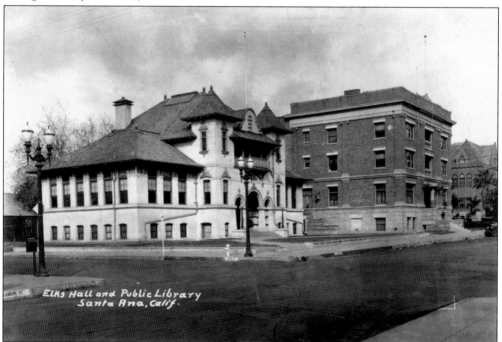

This is a 1930s photograph of the original Santa Ana library and Elks lodge. The Elks building was located near Sycamore and Sixth Streets. The old Orange County Courthouse is visible in the background at far right.

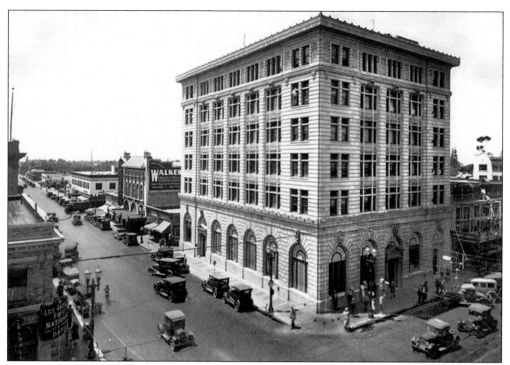

On the right of this photograph is the towering First National Bank Building. Next to it is a building under construction. Across the street is the Los Angeles National Bank. (Courtesy Bowers Museum of Cultural Art.)

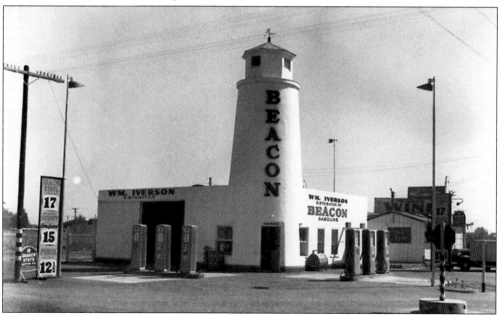

William Iverson was a distributor of Beacon Gasoline in the 1930s in Santa Ana. Walter Allen founded Beacon Oil Company in 1931 in Fresno, California. Through the years, the independent Beacon Oil Company has been sold to various companies. (Courtesy Bowers Museum of Cultural Art.)

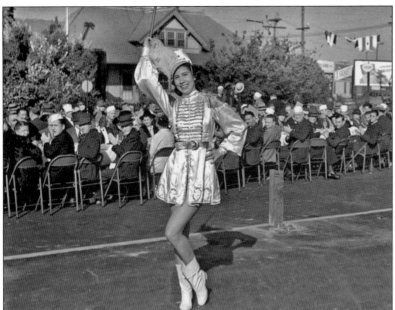

In the 1930s, a majorette strikes a pose during a gathering of the Santa Ana Breakfast Club. In the background, people are seated at long tables to enjoy conversation and breakfast. (Courtesy Bowers Museum of Cultural Art.)

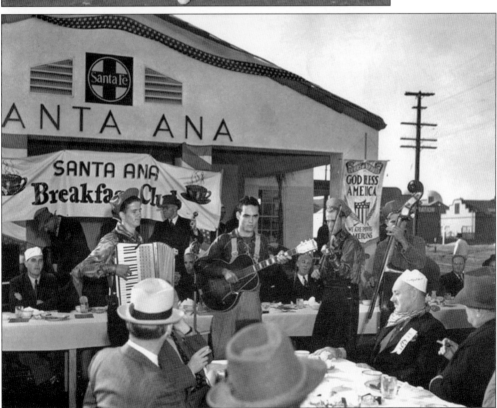

The Santa Ana Breakfast Club's musicians entertained guests. The breakfast meeting in this photograph was held on the grounds of the train depot. Look closely at the table in the foreground. It is interesting to note that people are smoking at the table. (Courtesy Bowers Museum of Cultural Art.)

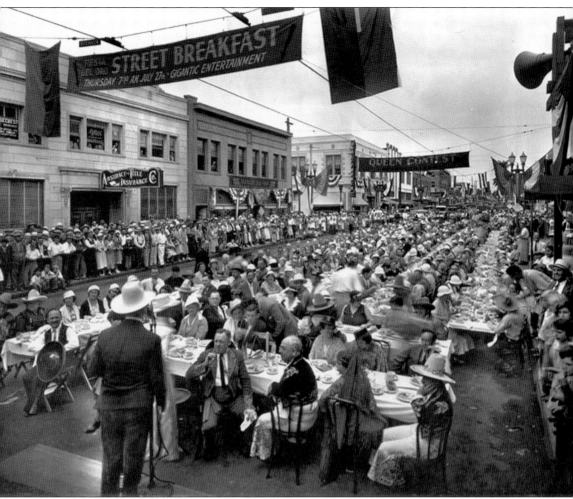

The Fiesta Del Oro Street Breakfast and celebration is pictured here in the early 1930s. The event was held on Main Street near Fourth and Fifth Streets. Santa Ana has a long history of community-oriented street parades and celebrations that continue up to modern days. (Courtesy Bowers Museum of Cultural Art.)

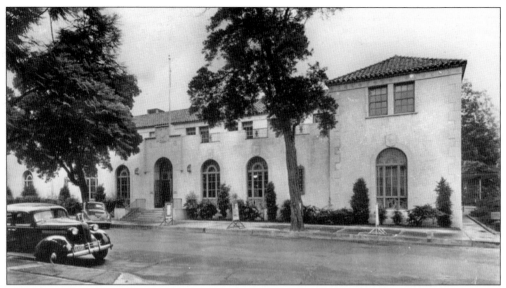

This post office, located at 605 Bush Street, is listed in the national registry of historic places. James A. Wetmore and his successor, Louis A. Simon, designed the building in the Mission/ Spanish Revival style. Simon worked for the U.S. Treasury for 45 years as supervising architect. He retired in 1941.

In the back of the Shaving Store in downtown Santa Ana, an unidentified man leans over a counter waiting for customers. After World War I, shaving supplies and toiletries grew in popularity. During the war, Gillette provided safety razors to every enlisted man going to Europe. In 1921, Lt. Col. Jacob Schick designed a razor that allowed users to change blades without touching the surface. (Courtesy Bowers Museum of Cultural Art.)

In the 1930s, Edward Cochems was one of the leading photographers in Santa Ana. He ran a successful business and loved to travel to Laguna Beach to take photographs of the Pacific Ocean. Many of Santa Ana's VIPs had their photograph taken by Cochem. (Courtesy Bowers Museum of Cultural Art.)

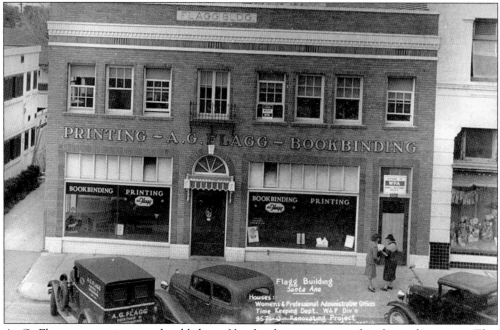

A. G. Flagg was a printer and publisher of books that were printed in limited quantity. This photograph of the Flagg Building shows a sign on the right for the administrative offices of the Women's and Professional Project, a division of the WPA. Two unidentified women are pictured on the sidewalk before going up to the WPA office. (Courtesy Orange County Archives.)

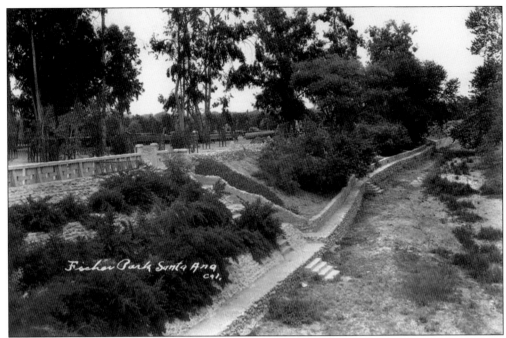

Jack Fisher Park was a central gathering spot for many residents of Floral Park. It is where outdoor concerts are held and where school-age children bounce around on the playground equipment. The neighborhood associations organize home and garden tours to raise money for charities, community parades, and holiday concerts. The Mothers of Floral Park also organize events for children.

Jack Fisher Park is located on North Flower Street. Jack Fisher was a local hero who served in World War I. He received a Purple Heart and the Medaille Militaire—France's highest military honor. Fisher died in 1929, and this park honors his name and reputation.

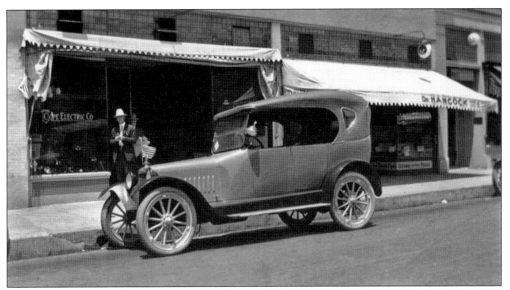

Two men stand on the sidewalk in front of Cope Electric and Company and the office of Dr. Hancock. Parked at the curb is a customized Dodge Brothers touring car. (Courtesy Bowers Museum of Cultural Art.)

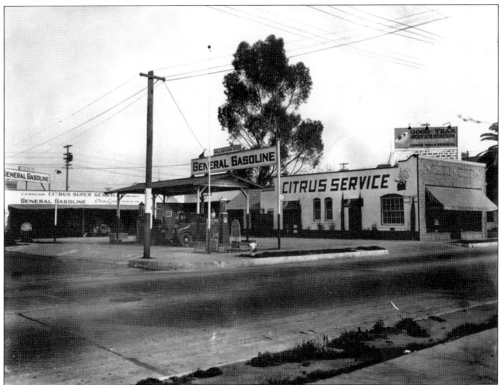

This is the Citrus Service and general gasoline station. This was a fairly large station for the period. Regular gasoline was around 20¢ per gallon and was sold without lead—it was typically 20 octane. Ethyl gasoline contained tetraethyl lead, which was added for the luxury cars that required 40 or more octane. (Courtesy Bowers Museum of Cultural Art.)

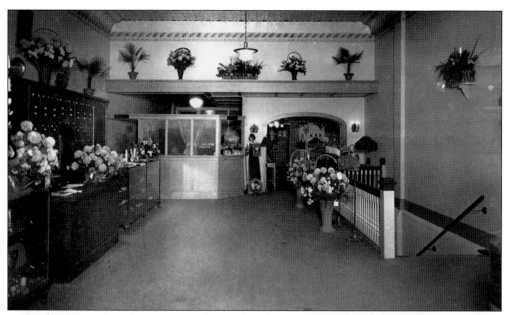

Sympathy flowers have been a part of funeral and memorial traditions in nearly every culture throughout history. Pictured is a flower store in downtown Santa Ana in the 1930s. On display are several large funeral arrangements. (Courtesy Bowers Museum of Cultural Art.)

This photograph is a view of North Main Street in 1935. On the corner is the Charcoal Broiler. In front of the store is a coin-operated scale. Many stores in the 1930s and 1940s had scales in front so that people could weigh themselves. Down the street from the Charcoal Broiler is Pandel's Food Market. (Courtesy Bowers Museum of Cultural Art.)

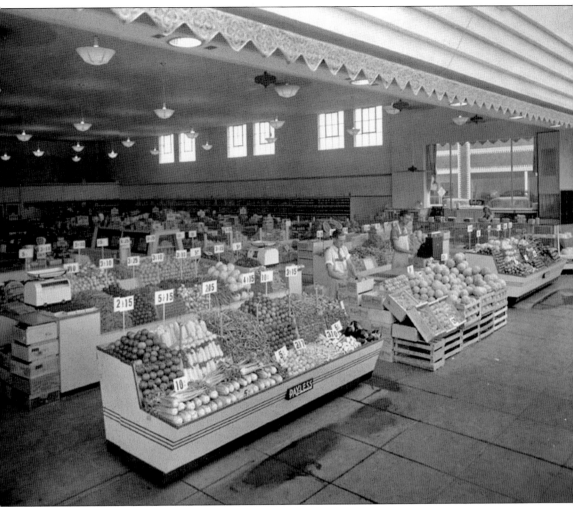

This most likely was the interior of the produce market at Grand Central Market, built in 1924. The market complex, which was located at Second and Broadway Streets, included several commercial businesses and was a bustling commercial area in the first half of the 20th century. This area has been refurbished and is now part of the Artists Village Redevelopment Area. (Courtesy Bowers Museum of Cultural Art.)

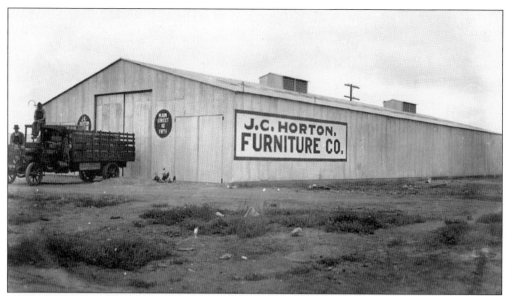

The family-owned J. C. Horton Furniture Company served Santa Ana for over 82 years, starting as I. R. Horton and Son in 1898. The photograph above shows the warehouse located between Fruit and Fourth Streets, next to the Santa Fe Railroad spur. At this time, J. C. Horton ran the company. The final Horton furniture store location was on Main Street, which was open until 1980. (Courtesy Bowers Museum of Cultural Art.)

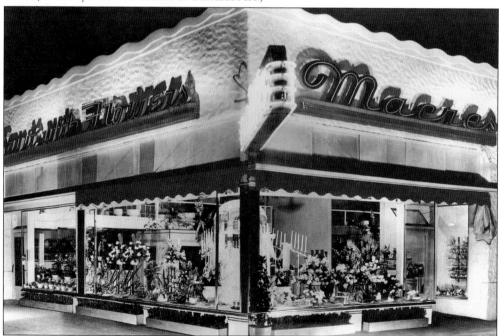

Macres Florists has been a mainstay on Broadway since the mid-1930s. This is the flower shop on opening night in December 1935. Originally owned by Harry Macres and his son Albert, the business is still family run, currently owned and operated by Albert's son Michael and his wife, Tricia. In the 1940s and 1950s, Macres Florists decorated award-winning Santa Ana floats for the Rose Parade.

In 1900, the Auto Club of Southern California was established. The association continues to provide motoring safety information, roadside assistance, maps and directions, and insurance services to over five million members. (Courtesy Bowers Museum of Cultural Art.)

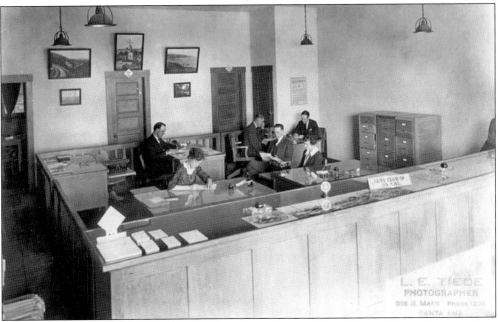

This is the interior of the Santa Ana Auto Club office in the 1930s. Office workers are busy working at their desks. (Courtesy Bowers Museum of Cultural Art.)

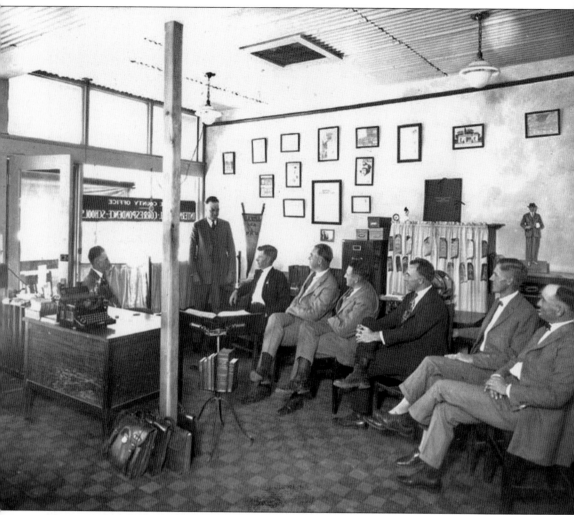

These unidentified men are pictured in the 1930s during a meeting at the Orange County Schools office. (Courtesy Bowers Museum of Cultural Art.)

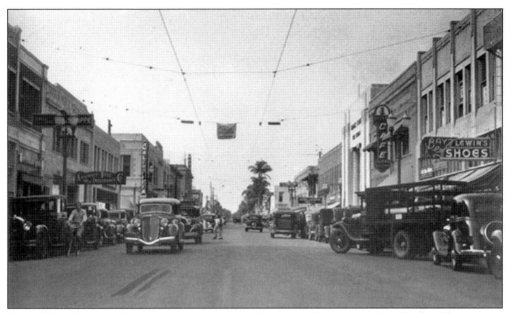

This 1930s photograph shows the busy business district of downtown Main Street. The street is filled with cars. On the left of the photograph, a man rides his bike through downtown traffic. (Courtesy Bowers Museum of Cultural Art.)

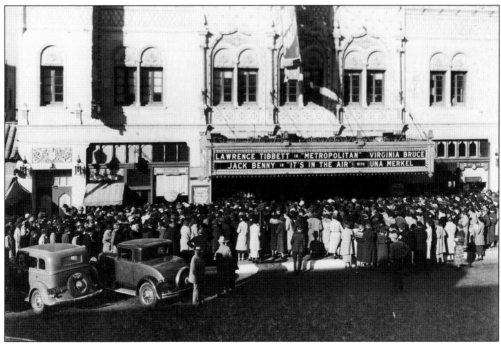

A crowd outside the Broadway Theatre in the mid-1930s anxiously awaits the opening of the movie *Metropolitan*, starring Lawrence Tibbett and Virginia Bruce, and *It's in the Air*, with Jack Benny and Una Merkel. (Courtesy Santa Ana Public Library.)

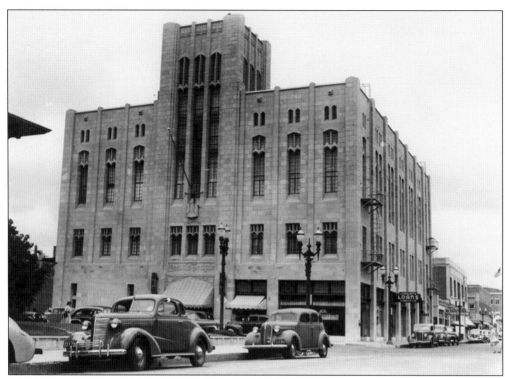

The four-story art deco Masonic temple at 505 North Sycamore Street was constructed in 1931. The building has 50,000 square feet of space and a full basement. In 1999, it was purchased by a developer and is used for the Santa Ana Arts and Events Center. It has been carefully restored to reflect the mood and the era when the building was created.

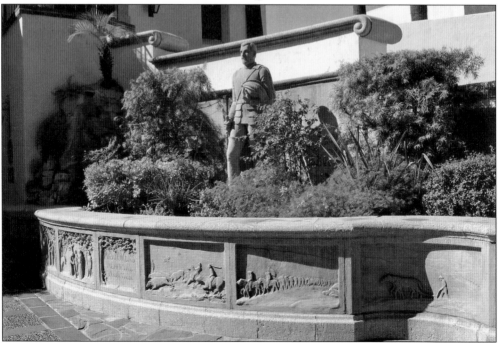

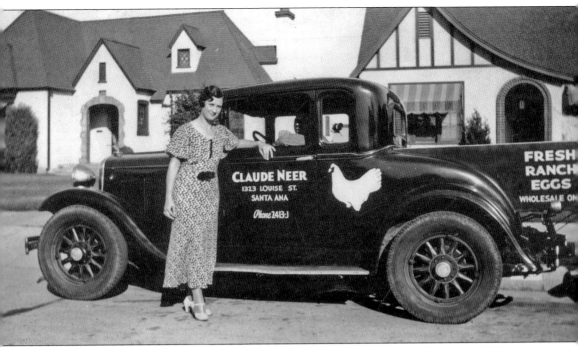

In the early 1930s, the Neer Egg Farm was started by Claude Neer from his home at 1323 Louise Avenue. Claude's business became very successful as he sold his eggs to markets like Alpha Beta and creameries like Excelsior and Ardens. After a few years, they moved to larger facilities at 1120 West Highland. Doris, Claude's wife, is pictured next to their first business delivery truck. (Courtesy Carol Anne Robison.)

OPPOSITE: Charles W. Bowers was an early Orange County land developer, and his wife, Ada E. Bowers, donated the land at 2002 North Main Street for the Bowers Museum. The main building was designed by architects W. Horace Austin and Frank Lansdowne. It was built in 1932. The current buildings have been substantially expanded from the original construction. The original museum, which is a Mission-style, two-story building, now forms one side of the central courtyard. During the Depression years, the museum was closed due to lack of funds. The museum is listed on the registry of Santa Ana historic landmarks. The museum is one of only 750 museums in America accredited by the American Association of Museums, and is the only museum in the United States to partner with the British Museum. This hand-carved stone work located in the courtyard looks almost the same as when the museum was built. As this book is being published, the museum is in the midst of another expansion. (Courtesy Marge Bitetti.)

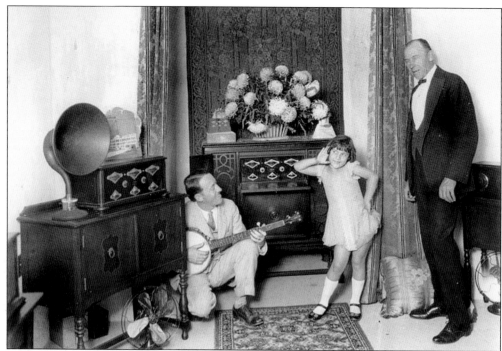

The person in the center of this photograph looks like Darla Hood, a child actress from the 1930s and 1940s. The two men are unidentified. During the 1930s, many Hollywood stars stopped in Santa Ana. A popular location was the Daniger Tea Room in the Santora Building. All the top celebrities of the time enjoyed the fine foods created by Joe and Irene Daniger. (Courtesy Bowers Museum of Cultural Art.)

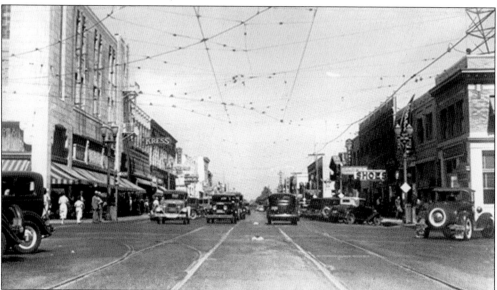

This photograph shows downtown Santa Ana in the 1930s. High above the cars are the electric wires for the Pacific Red Car. The electric rail connected more than 150 cities in Southern California. Passengers were able to ride from as far north as San Fernando, with stops in many Los Angeles and Orange County cities. (Courtesy Bowers Museum of Cultural Art.)

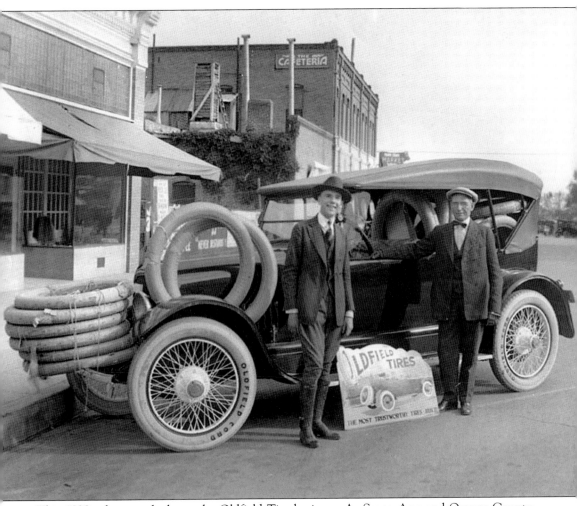

This 1930s photograph shows the Oldfield Tire business. As Santa Ana and Orange County grew, automobiles became the transportation of choice, creating opportunities for businesses providing products and services tailored to the needs of the car owners. Two unidentified men are seen with a car advertising the quality of Oldfield Tires—"The Most Trustworthy Tires Built." (Courtesy Bowers Museum of Cultural Art.)

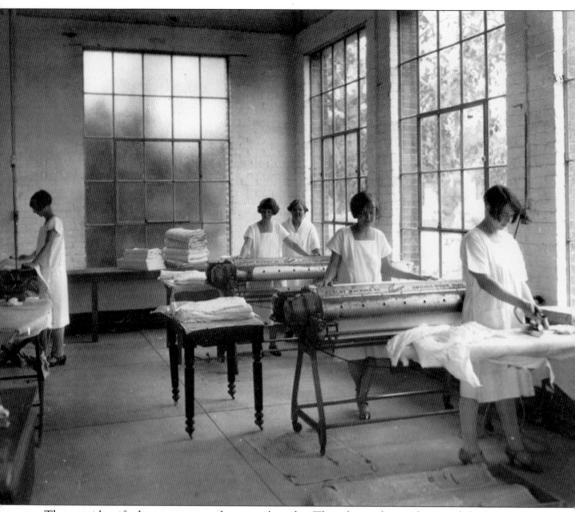

These unidentified women are working in a laundry. The job was demanding, and the hours were long. Standing at steam presses for long periods of time was exhausting and physically difficult. The temperatures in the laundries were between 95 and 115 degrees each day. (Courtesy Bowers Museum of Cultural Art.)

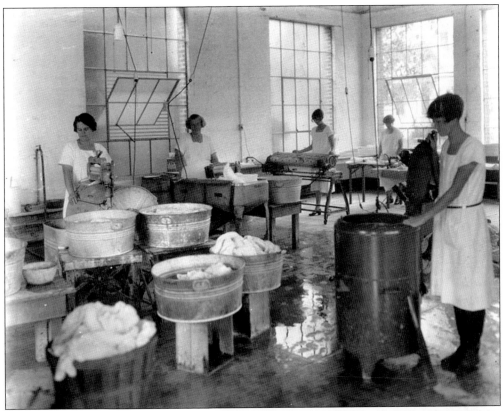

Women did most of the work in laundries, including washing, starching the clothes, ironing, folding, and packing the cleaned garments. (Courtesy Bowers Museum of Cultural Art.)

A large crowd waits outside of this Latino store for the sale. Signs posted in the store window state that "the sale begins Thursday." The clothing store was located at 310 Fourth Street in downtown Santa Ana. (Courtesy Bowers Museum of Cultural Art.)

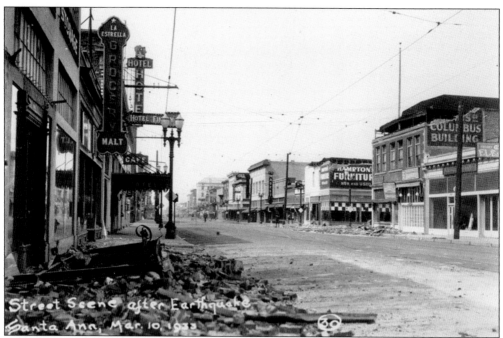

An earthquake with a magnitude of 6.3 struck Southern California on March 10, 1933. The earthquake was centered off the coast, near the city of Long Beach. After the earthquake, there were 78 aftershocks. As a result, some buildings needed to be torn down or rebuilt. There was extensive property damage in Santa Ana. (Courtesy Bowers Museum of Cultural Art.)

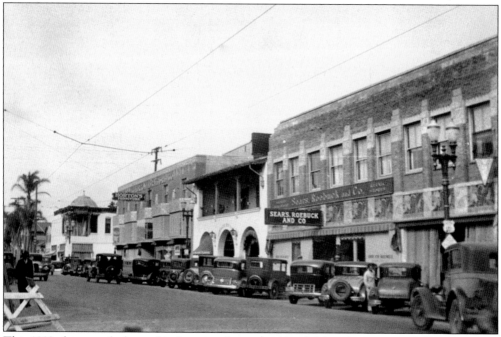

This 1933 photograph shows the shopping district on North Main Street, near Fifth Street. The businesses, pictured from left to right, included Horton's Furniture; the Arcade Building; and Sears, Roebuck, and Company. (Courtesy Orange County Historical Society.)

People line the street outside this Salvation Army. William Booth, a Methodist minister, started the Salvation Army in England. In 1887, the Salvation Army began working in Orange County providing food and shelter to the homeless. This photograph was taken during Christmas, as indicated by the sign requesting donations for Christmas baskets. During the Depression, there were many who went to the Salvation Army for assistance. The Salvation Army is still active around the world, providing service to over 33 million people. (Courtesy Bowers Museum of Cultural Art.)

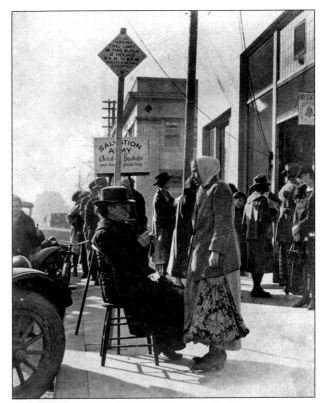

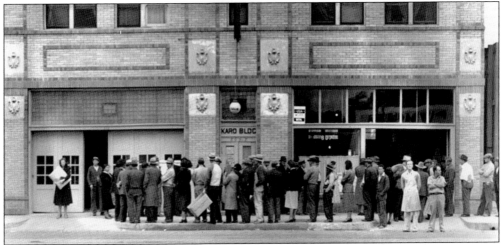

This is a photograph of the WPA Food distribution center in downtown Santa Ana. The 1929 crash of the stock market was followed in 1931 by a drought that spread across the Midwest plains states. With lack of rain on the rich farmland, the crops could not grow and livestock did not have food to eat or water to drink. People lost their homes, their farms, and did not have enough food for their families. Over two million people left the plains states to seek a new opportunity. Many of these people came to California but found a lack of jobs and opportunities. The federal government provided these numerous unemployed people with food through the WPA. In this 1939 photograph, people wait with boxes to receive free food distribution. (Courtesy Orange County Archives.)

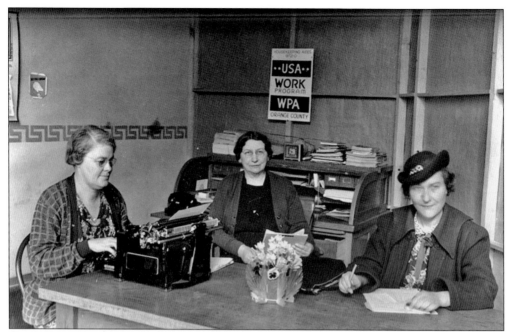

In addition to the WPA, the federal government provided assistance through the Public Works Administration (PWA) and the Civil Works Administration (CWA). The Works Progress Administration of 1935 continued the work of building and improving a wide variety of public facilities. The WPA assisted communities in expanding educational, library, health-related, and other community projects. (Courtesy Orange County Archives.)

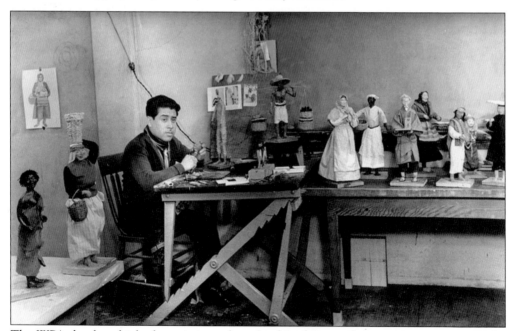

The WPA developed jobs for artistic workers. In this photograph, a museum assistant in the WPA works on displays items being readied for a display at the Bowers Museum. (Courtesy Orange County Archives.)

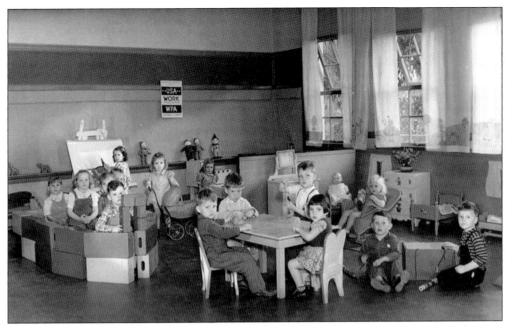

WPA nursery schools were established to provide childcare for women who were working in WPA projects. This late-1930s photograph shows the nursery school, Hoover School. (Courtesy Orange County Archives.)

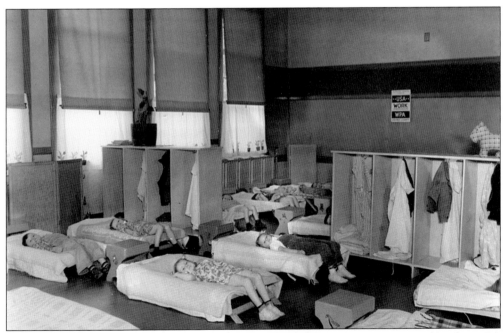

This is a photograph of rest time at the Hoover Nursery School. Programs started by the WPA program such as nursery-school care are still vital in society. Although the programs of the 1930s and 1940s have undergone many changes, the roots can be traced to many of the WPA programs. Examples of this include school lunch programs, home health care, and nursery schools for low-income groups as well as historic preservation. (Courtesy Orange County Archives.)

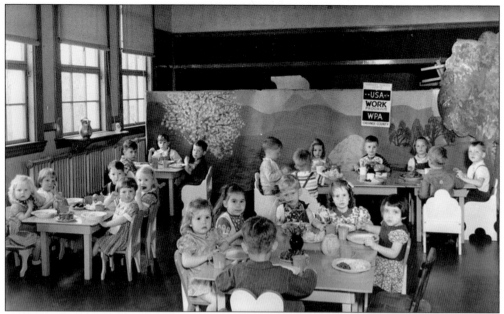

Women were in charge of the WPA nursery programs. Many women's work projects provided services that were needed and appreciated so much by their communities that they were continued in some form after the end of the WPA. The nursery school program was important because it allowed many women to work and help with the family's economy. (Courtesy Orange County Archives.)

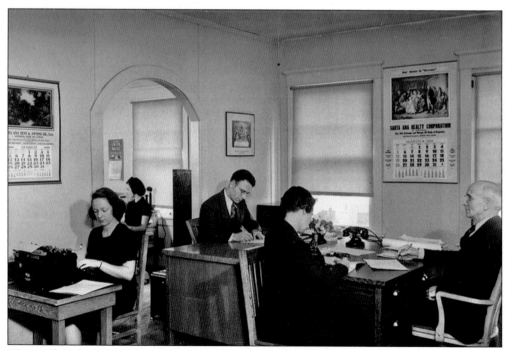

The staff of the WPA administration office in Santa Ana are pictured at work. The calendar indicates that it is March 1939. (Courtesy Orange County Archives.)

Six

1940s

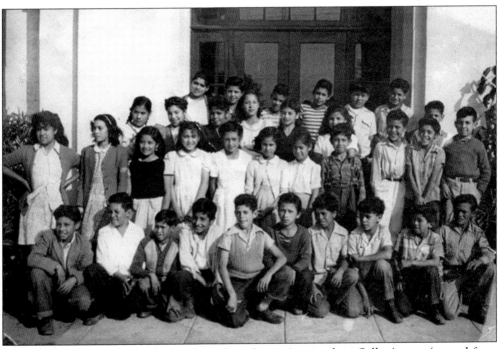

Many low-income and minority students from Santa Ana, such as Sally Acosta (second from left in second row), were required to attend Hoover School in Westminister, California. This 1940s photograph shows the students from the Santa Anita barrio in West Santa Ana who attended Hoover School. In Orange County, there were nearly 47 barrios. Most of them have disappeared. The Mendez children attended Hoover School at the time their parents, Sylvia and Gonzalo Mendez, filed the class-action lawsuit regarding segregation of Mexican American students in California. The case of Mendez (et al) v. Westminister (CA) School District in 1946 involved the four school districts of Santa Ana, El Modena, Garden Grove, and Westminister. (Courtesy Sally Gutierrez Acosta.)

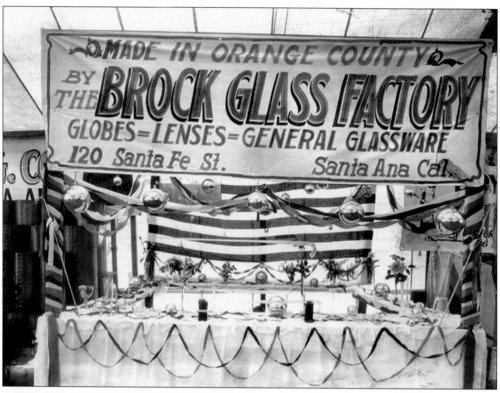

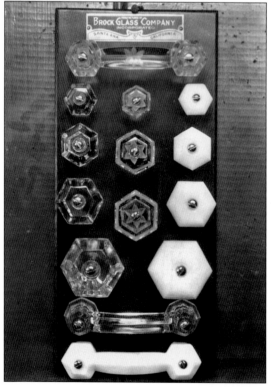

Brock Glass Factory of California was a glass products manufacturer founded in 1947 by Bert Brock. It closed in the mid-1950s. Bert Brock is probably better known for his abstract art, rather than his pottery, but the company did produce a number of dinnerware patterns. (Courtesy Bowers Museum of Cultural Art.)

Brock also manufactured a line of glass drawer and door handles. This photograph shows samples of the various items that the company produced during their short history. (Courtesy Bowers Museum of Cultural Art.)

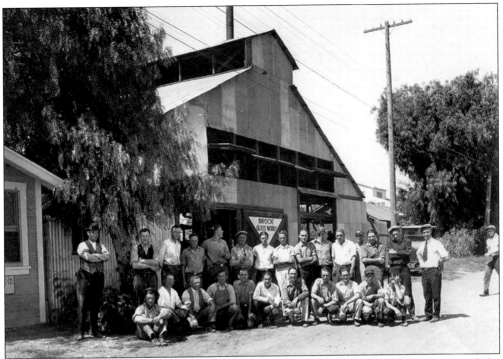

Employees pose outside the Brock Glass Factory in Santa Ana, a successful business until the early 1950s. (Courtesy Bowers Museum of Cultural Art.)

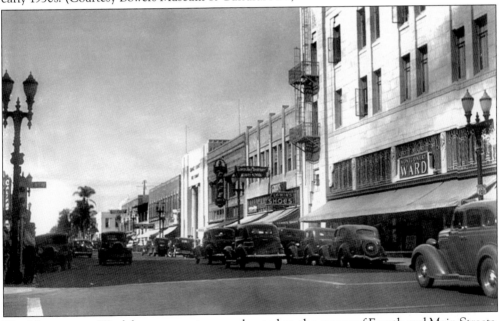

The Montgomery Ward department store was located on the corner of Fourth and Main Streets. In the 1960s, the store moved to the Honer Plaza shopping center on Seventeenth and Bristol Streets. The charming, original building was demolished in 1975. After 128 years in the retail business, Montgomery Ward closed all their stores in March 2001. (Courtesy Bowers Museum of Cultural Art.)

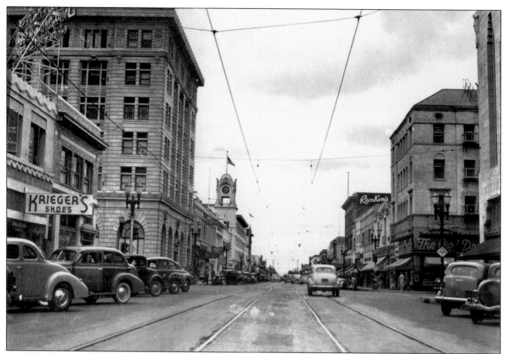

Downtown Santa Ana is pictured here in the 1940s. On the left is Krieger's Shoes, in the background is the Spurgeon Building with its clock tower, and on the right are the Owl Drug and Rankin's department store. (Courtesy Bowers Museum of Cultural Art.)

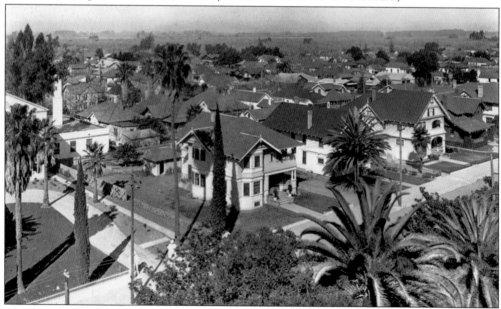

This late 1940s photograph is an aerial view of some of the community. Santa Ana has over 50 designated neighborhood areas where residents work together to create a better community through clean-up projects, events, parties, and even historic home tours. Today's residents continue the "can do" attitude of their ancestors over 140 years ago. (Courtesy Bowers Museum of Cultural Art.)

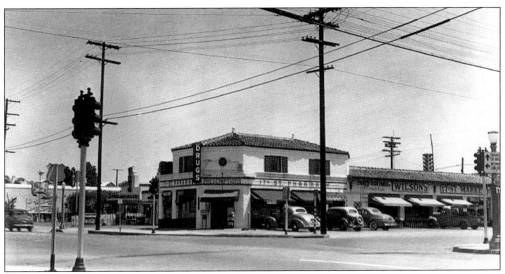

The pharmacy on Seventeenth Street was established in 1948 on the corner of Main and Seventeenth Streets. The building was designed in the Mission style. (Courtesy Orange County Historical Society.)

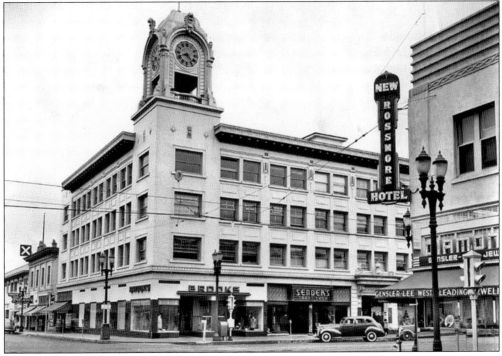

The William H. Spurgeon Building was built in 1913 and still stands as a symbol of Santa Ana and the legacy of the city's founder. The classical Revival–style building was designed by Metcalf and Davis of Long Beach. The clock tower stands 32-feet tall and for many years was the tallest building in the city. The clock was restored to working order in a restoration project led by the Santa Ana Historical Preservation Society thanks to community volunteers and donations from residents and local businesses. The building is located at 206 West Fourth Street near the corner of Fourth and Sycamore Streets. (Courtesy Bowers Museum of Cultural Art.)

In 1931, the Masonic lodge was dedicated. It was the fifth of the Masonic temples built in Santa Ana. It cost $300,000 to build each temple. Each was more stylish than the one before. This hall was used for meetings of Santa Ana Lodge No. 241 F&AM until 1984, when it was closed due to concerns about the structure's ability to withstand a major earthquake. In the late 1990s, the building was fully restored and reborn as the Santa Ana Arts and Events Center, where many galas and events take place today. (Courtesy Bowers Museum of Cultural Art.)

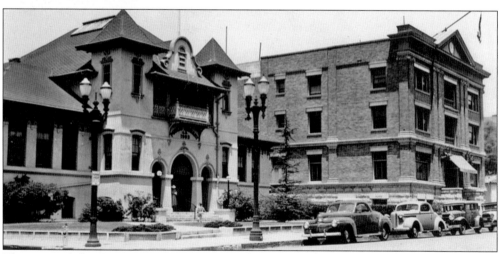

This view of the Santa Ana Carnegie Library was taken in the 1940s. Next to the library is the Elks lodge, located on Sycamore Street between Fifth and Sixth Streets. The library originally started in 1887 and was moved to several locations before a grant of $15,000 was obtained from the Carnegie Foundation in 1902. City founder William Spurgeon donated the land, and architects Bither, Dennis, and Farwell designed the Spanish Revival–style building. Philanthropist Andrew Carnegie was responsible for over 2,500 libraries worldwide. In the United States, he built 1,681 libraries. The local community was required to provide the land and the ongoing support was to come from local tax revenue. Only 36 of the 142 original Carnegie public library buildings in the state of California are still used as libraries—21 are museums, 13 are used for community services, and the remaining 15 have a variety of uses.

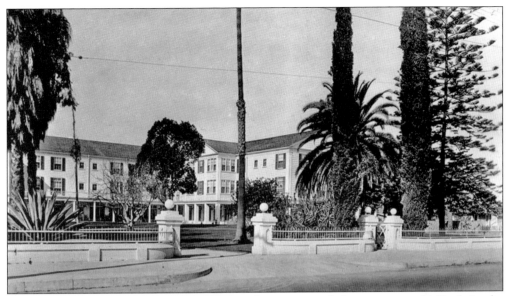

An early brochure for St. Ann's Inn on Broadway promised that guests would "bask in the sunshine of Southern California tempered by the cooling breezes from the broad Pacific—just ten miles away." A single room on the European plan was just $3.50 a night.

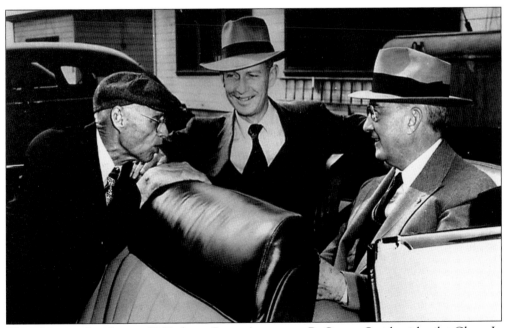

This photograph, taken in 1947, shows Santa Ana mayor R. Carson Smith with pilot Glenn L. Martin and an unidentified third man. In 1909, Martin was the first person to fly in California. In 1912, he flew from Newport Beach to Catalina, making this historic 34-mile flight in 37 minutes. He was the first person to successfully fly across a large body of water. Martin went on to fame and fortune, founding the Glenn L. Martin Company and building many planes for the government during the war. He contributed to many local organizations. (Courtesy Bowers Museum of Cultural Art.)

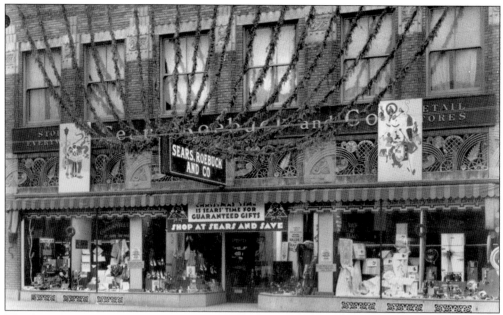

The Santa Ana Sears store is seen decorated with garland for the holidays. After World War II, there was an increase in the population in Santa Ana. In 1940, there were just over 31,000 people living in the city, however, by 1950, there was a dramatic increase to 45,000. There was an increased demand for modern stores with the large number of new residents. (Courtesy Orange County Historical Society.)

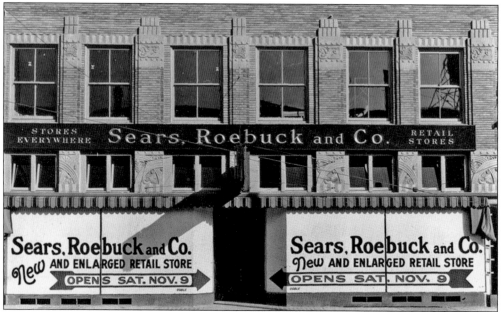

Sears opened a store about one mile south of downtown Santa Ana on Main Street. In the 1940s, a remodeled store opened to serve the residents of Santa Ana. Sears and Roebuck, J. C. Penney, and Montgomery Ward were all located in the downtown area. Each of the stores was in competition with other for the business of local shoppers. (Courtesy Orange County Historical Society.)

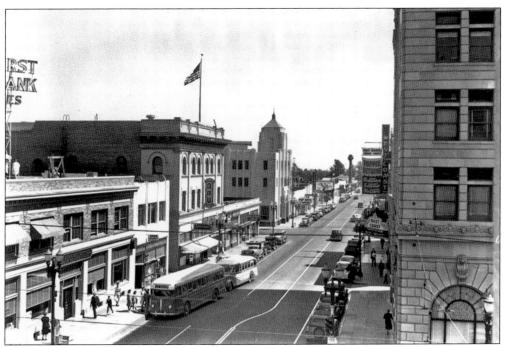

This is Fourth Street in 1941. A corner of the First National Bank is visible, as are the West Coast Theater (in the middle of the block) and the old city hall (center). The movie *Topper Returns* is featured. This series of comedies was so popular that the original *Topper* (1937) movie inspired *Topper Returns* and *Topper Takes a Trip* (1939) as well as the Topper television show in 1953. In all these comedies, a fun-loving couple of ghosts visit a wealthy unassuming banker, who is the only one who can see the mischief-causing spirits. (Courtesy Bowers Museum of Cultural Art.)

Joseph Gomez Jr., age three, is playing on his toy tractor in front of the home of his parents, Jose and Rafaela Gomez. Growing up on Adams Street in the Delhi neighborhood was warm and joyful and rarely lacked the necessities of life or life's extras, as evidenced by the toys and the newer car in the photograph. Employment was abundant in Delhi, with many residents working at one of the two local sugar factories. (Courtesy Harvey Reyes.)

The chamber of commerce, started in 1888, was originally known as the Board of Trade. In 1893, this organization changed its name to the Santa Ana Chamber of Commerce. The goal of the organization was to promote city real estate, local businesses, and foster city pride. The original chamber building is now home to the nonprofit organization Taller San Jose, located at 801 North Broadway Street. This organization assists and empowers people and helps them become economically self-sufficient.

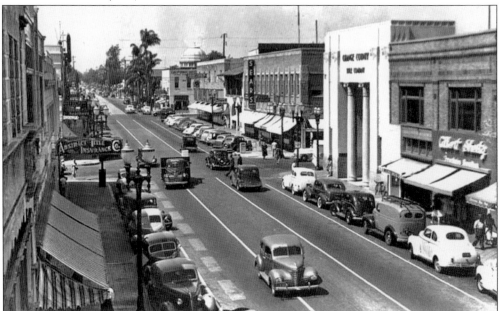

This 1946 photograph shows various businesses on Main Street. On the right is the Orange County Title Insurance Company and Sears. The building with the round dome at the far end of the street is the Congregational church. On the left is the Abstract Title Insurance Company. (Courtesy Bowers Museum of Cultural Art.)

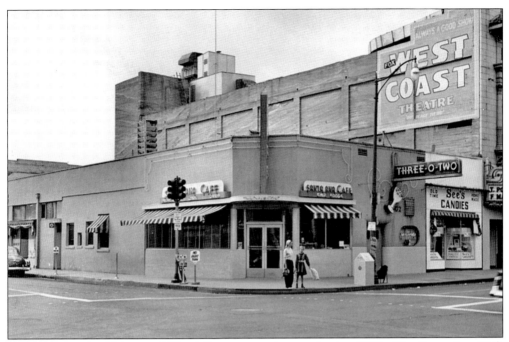

This photograph of Main and Third Streets was taken in the late 1940s. The Santa Ana Café was located on the corner. Next door were Three-O-Two Cocktail Lounge, See's Candies, and the Fox movie theater. (Courtesy Bowers Museum of Cultural Art.)

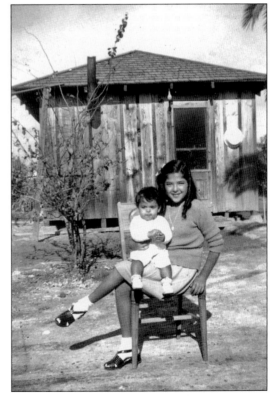

In this early 1940s photograph, Virginia Gomez is pictured holding her cousin Christina Castaneda in the backyard of her parents, Jose and Rafaela Gomez, home on Adams Street in the Delhi neighborhood. Delhi was (and still is) one of several Hispanic barrios (neighborhoods) in Santa Ana, including Logan and Artesia. (Courtesy Harvey Reyes.)

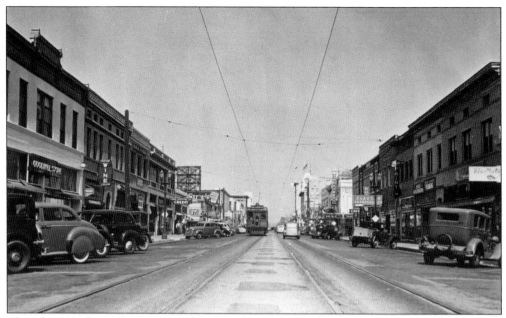

This photograph, looking east on Fourth Street, dates to the 1940s. Pictured in the center is a streetcar, once a popular mode of transportation. The Spurgeon Building is on the right. (Courtesy Rob Richardson.)

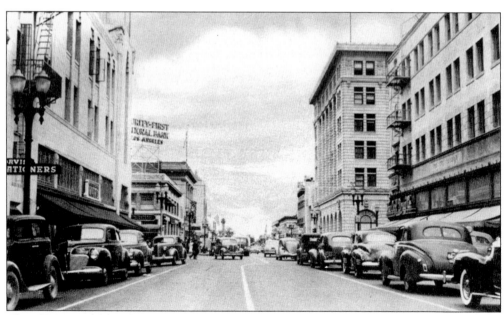

This 1940s view from the corner of Fourth and Main Street looks south. On the left of the photograph is the Security First National Bank of Los Angeles and the Montgomery Ward store. Montgomery Ward started in 1872 in Chicago and pioneered the mail-order catalog industry, established 14 years before its competitor Sears and Roebuck. On the right is the Otis Building.

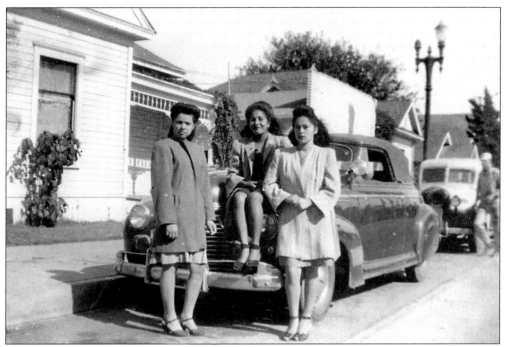

As today, fashion was important to the younger people of the neighborhood and care was taken to display the latest trends. Amelia Lujan, Librada Valenzuela, and Anita Villalobos are seen in this 1940s photograph near their homes in Santa Ana. (Courtesy Harvey Reyes.)

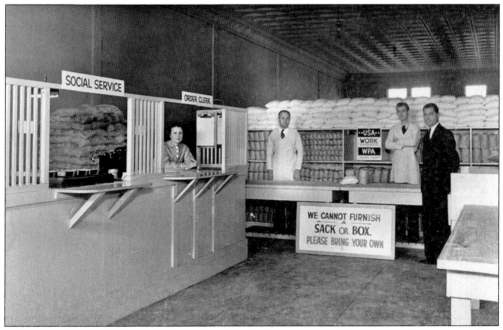

Following the Great Depression, there were federal surplus commodities centers. These food banks allowed people on federal assistance to get food and clothing. This was the surplus commodities distribution center in Santa Ana. (Courtesy Orange County Archives.)

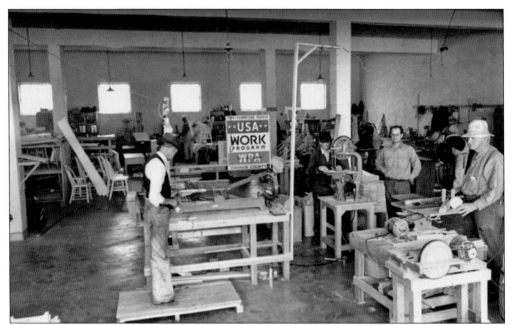

Men and teenage boys were hired by the WPA to repair toys and furniture at the Santa Ana WPA furniture repair location that was active from the late 1930s to the mid-1940s. (Courtesy Orange County Archives.)

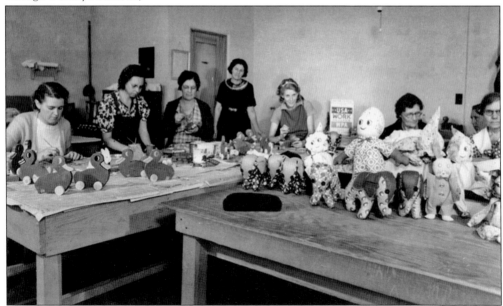

From 1936 to 1943, Pres. Franklin Delano Roosevelt persuaded Congress to create the Public Works Administration (PWA) and the Works progress Administration (WPA). Both created jobs and stimulated business. The Great Depression had robbed children of the opportunity to have even one toy because the parents had lost everything. Inspired by fears that children without toys would become juvenile delinquents, a toy lending library program was created. This photograph shows toys being painted at the Santa Ana WPA program. (Courtesy Orange County Archives.)

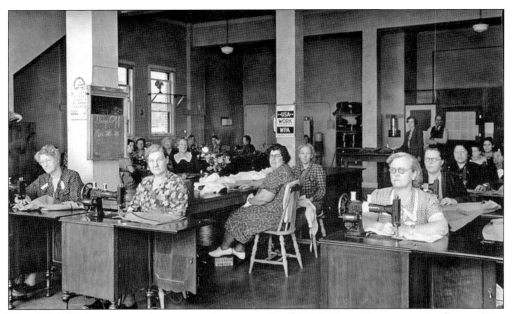

The WPA had programs for men and women. At this WPA sewing center in Santa Ana, women are using their skill to sew garments. The WPA enabled women to work to support their families. They were paid for their work and the garments were distributed to families on federal assistance. (Courtesy Orange County Archives.)

In this photograph, taken when the Orange County Courthouse was named to the list of California's historical landmarks, Orange County historian Jim Sleeper poses with Mrs. Weston Walker. The head of the movement for the original courthouse to be recognized in the history books, Walker also cofounded the Santa Ana Historical Preservation Society during her fight to save the Dr. Willela Howe-Waffle House from demolition. (Courtesy Orange County Historical Society.)

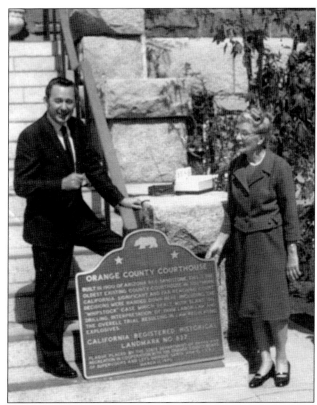

BIBLIOGRAPHY

Ball, Guy. *Santa Ana in Vintage Postcards.* Charleston, SC: Arcadia Publishing, 2001.

http://www.broward.org/library/bienes/lii10202.htm

Bitetti, Marge. *Millennium 21st Century Orange County.* Pioneer Press, 1999.

http://carnegie-libraries.org

http://www.cochems.com

http://www.cinematreasures.org

http://www.fairhavenmemorial.com

Les, Kathleen. *A Guide to Santa Ana's Historic Neighborhoods.* Santa Ana Historic Survey, 1980.

Marsh, Diann. *Santa Ana: An Illustrated History.* Encinitas, CA: Heritage Publishing, 1994.

Old Orange County Courthouse, Orange County Public Facilities and Resources Department, with the cooperation of Orange County Historical Commission.

Rediscovering Historic Downtown Santa Ana; a walking-tour guide published by the Santa Ana Historical Preservation Society, 2000.

http://www.santaanahistory.com

Schultz, Elizabeth, ed. *Visiting Orange County's Past.* Santa Ana, CA: Orange County Historical Commission, 1984.

Sleeper, Jim. *Orange County Almanac of Historic Oddities.* Santa Ana, CA: Ocusa Press, 1971.

Swanner, Charles D. *Santa Ana: A Narrative of Yesterday.* Saunders Press, 1953.

Taylor, Ruth Ellen, ed. *Legacy, The Orange County Story.* Santa Ana, CA: *The Orange County Register,* 1980.

Wheeler, Roy S. *A Century of Reflection, Santa Ana Lodge No. 241, 100th Anniversary, History of the Masonic Lodge,* 1976.